THE ART OF DRAWING
MANGA

BEN KREFTA

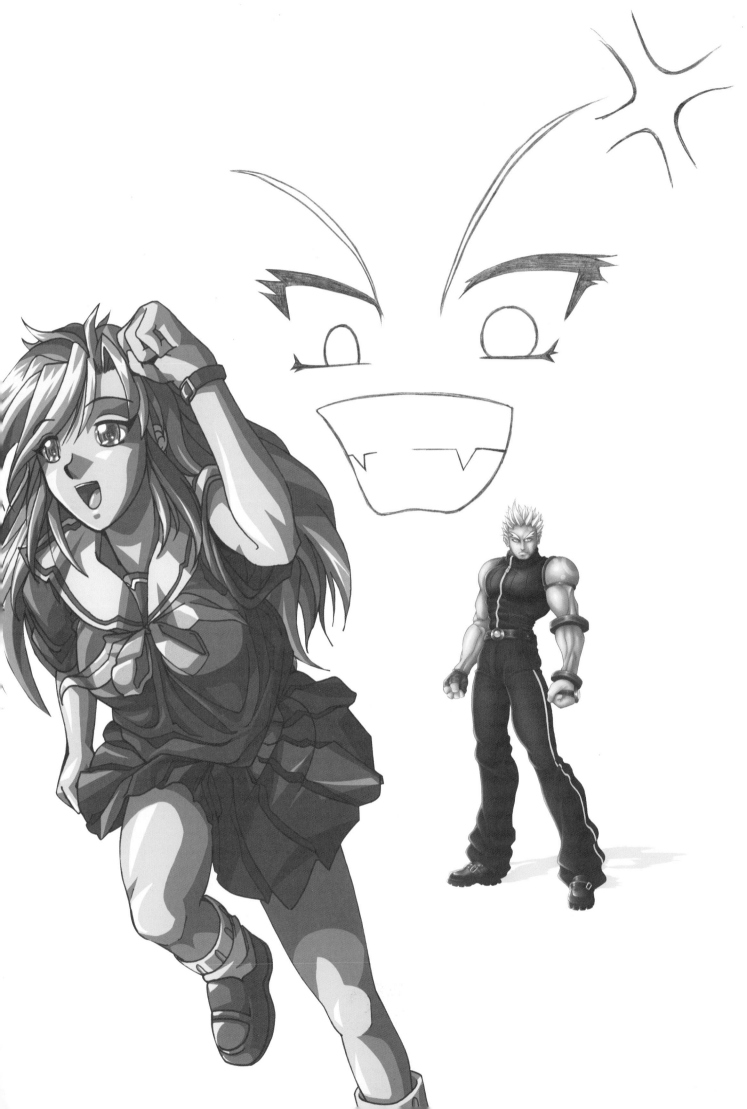

THE ART OF DRAWING
MANGA

BEN KREFTA

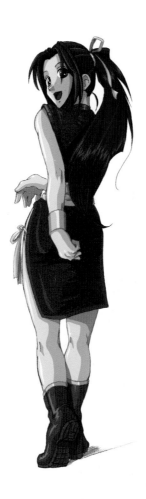

ARCTURUS

ARCTURUS

This edition published in 2012 by Arcturus Publishing Limited
26/27 Bickels Yard, 151–153 Bermondsey Street,
London SE1 3HA

ISBN: 978-1-84193-171-5
CH000564US
Supplier 16, Date 0312, Print Run 1249

Printed in Singapore

ACKNOWLEDGEMENTS

I would like to thank the following for their invaluable help in creating this book:

Kim Loh from Malaysia

webmaster@neo-epiphani.com

website: http://www.neo-epiphani.com

Kim created the groovy red bikini girl (page 71).

&

Dan Fielding aka Cloud from the UK

cloudstrife@yahoo.com

website: http://www.cloudsgallery.com

Dan is the talented artist of the warrior maid (page 81),
the running girl (page 97) and the action pic of the girl
with two guns (page 142).

Last but not least a big thanks to my brother James Krefta for his
invaluable help in putting the text together.

INTROD

Times are changing—exciting 'anime' and 'manga' artwork has finally been recognized here in the West for its exotic designs, flair, and wonderfully distinct style. Nowadays we see it in entertainment media such as magazines, comic books, television, advertising, graphic design, and websites, and even at the movies. Yet not so long ago it was a genre of art restricted to audiences in Asia.

What are these art forms?

Basically, manga are comic books and the word 'anime' means animation. When these Japanese terms are used, they generally refer to original Japanese creations and not to those created elsewhere. However, so many people all over the world are being inspired by the manga style that such work now has its own descriptive title—'pseudo manga'.

'Manga' literally translates as 'irresponsible pictures' and it is argued that the first examples were Chinese temple wall paintings of Shaolin monks practicing martial arts. More recently, Japanese comics proved popular throughout the 1960s with the serialization of numerous stories, including Osamu Tezuka's 'Mighty Atom', which later became a long-running anime between 1963–1966.

Ironically, the origins of early Japanese animation were heavily influenced by the American cartoons of the 1950s—Betty Boop for example, with her big, wide eyes. These were then adapted by Japanese artists and were a notable inspiration for modern anime character design.

Why has 'manga' become so popular and how is it different from Western comics?

For many years, it has been a widely accepted art style within Japanese culture, and it is here that 'manga' was born. In Japan, manga artists and writers are as celebrated as best-selling authors and artists in the West. Every week in Japan, huge volumes of manga comics are printed and read by millions of people of all ages. Indeed, the popularity of manga can be largely attributed to the diversity of genres within it which appeal to every age and gender. Subjects can vary from romance to high school sports teams, from outer space battles with huge, mechanical warriors to occult horror, and even traditional folklore—to name but a few.

It is here that we notice the first difference to Western comics; few manga stories, for instance, are based on

UCTION

superheroes but tend to focus on average people thrust into extraordinary circumstances. Perhaps we have come to identify more closely with manga characters because they give us a very different take on the types of superhero stories and art style that we are accustomed to.

Technically there are several key differences between the art in Western comics and manga. Manga tends to rely less on heavy shading and uses smooth line art. While the characters may often appear simplistic in the way in which they are drawn, the overall attention to detail is astounding, especially in backgrounds where the picture is composed as a whole entity rather than as aspects added on as an afterthought. Then there is the humor in manga—even if the story is

not a comedy, several artistic conventions are used to emphasize gestures and the expressions of characters.

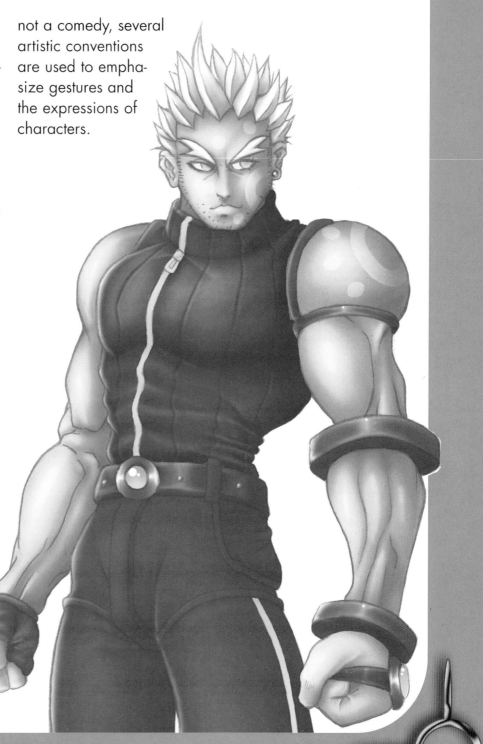

Examples include the big sweat drop on the brow to indicate tension, the small mushroom-shaped cloud from the mouth depicting relief, and a bulging vein at the side of the head to convey frustration or anger.

Many Western artists and publishers are now producing pseudo manga and releasing original titles. This isn't a case of 'jumping on the bandwagon'—it is because we like what is offered by the medium, its freshness and excitement. Manga isn't a fad, it is here to stay!

In this book, you are presented with step-by-step instructions that show you how to create manga illustrations. The style is suitable for manga, anime, or video game design, and is in keeping with the most popular Japanese techniques and aesthetics. The approach is intended for novice manga artists with some basic knowledge of drawing. It is presented in a way that should be helpful if you are learning for the first time. As such, sections are broken down to focus on particular

areas—the male/female head, face, hair, and body. The budding artist can then move on to designing character clothing and accessories, finally mastering the creation of his or her very own characters.

It is my hope you will enjoy this book and have a lot of fun generating wonderful manga artwork. The key is to keep on practicing.

With this solid grounding, you'll soon be producing manga as good as that of your favorite professionals. Keep this thought in mind and remember that there was a time when even THEY couldn't draw! *Everyone has to start somewhere…*

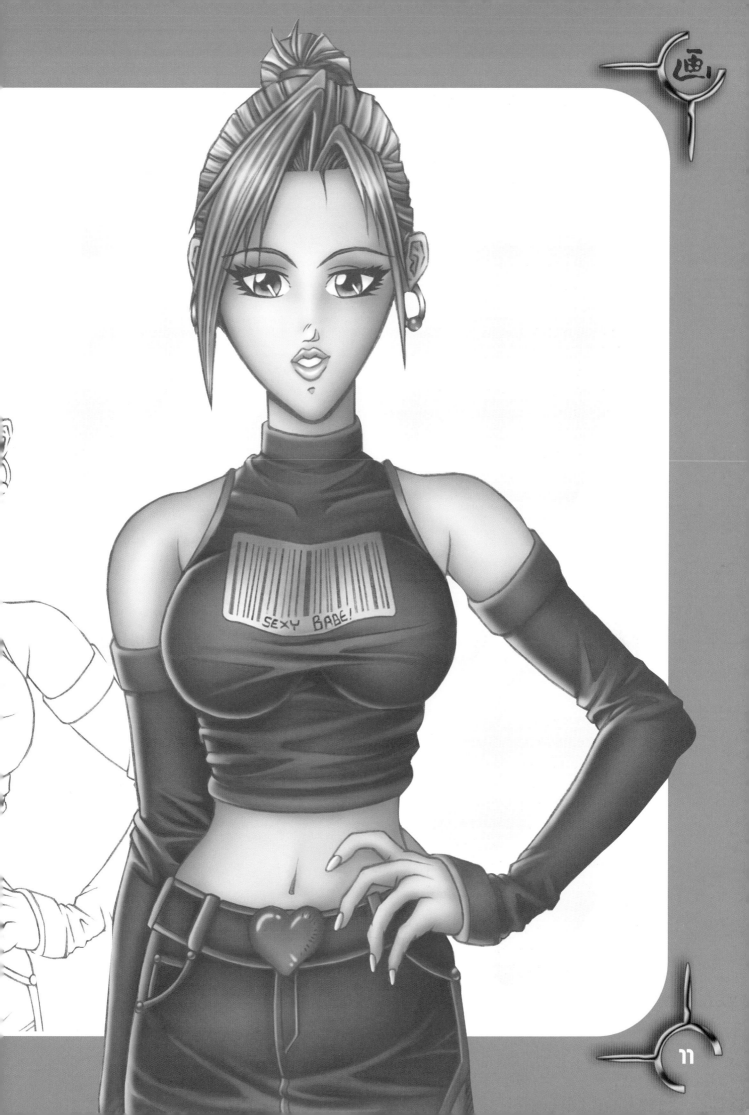

MATE
& TOO

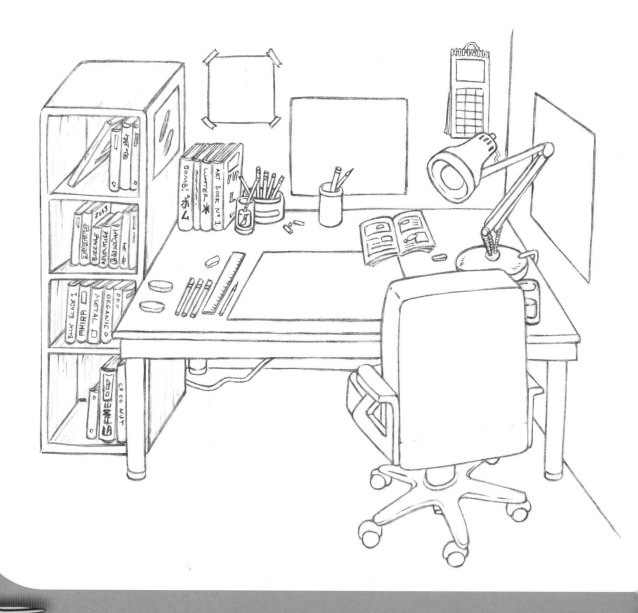

If you're new to drawing and just want to get stuck in, you'll need three basic items: a pencil, an eraser, and paper. As you become more skilled and confident at drawing, you should try experimenting with better-quality materials and different tools to make the most of your work.

Using good-quality materials will give better results and enhance your overall picture. The next stage should be using several pencils of varying densities for shading purposes and heavier-grade paper.

You may want to ink and color in your pictures as well, in which case you'll need to use more tools for these tasks, all of which are detailed in this section.

Experienced artists have their own preferences for materials, depending on their style and favorite medium. This is something which you'll develop gradually, but in the meantime, have some fun playing around with different materials. It's just as important to discover a material that you don't like as it is to find one that you love.

On the following pages, we'll go through the array of materials that you can use as a budding manga artist and outline the advantages and disadvantages of each medium. The pros and cons of each medium shouldn't be pitted against one another in order to find the 'perfect tool', but merely taken as points of consideration.

PENCILS

The first tool you'll need to acquire is a pencil—ideally, a range of pencils varying from a hard 3H to a soft 2B. In manga artwork, you need to maintain smooth, clean lines, so using anything darker than 2B will result in smudging that cannot be easily removed with an eraser. Not only that, but clean line art makes the inking stage easier to do (where black outlines are put down on the illustration and shadows added).

Whether you choose to use a mechanical pencil or an ordinary wooden one, pencils are the standard medium used to draw manga—from layouts and sketches to the final illustration—so it's crucial to practice using them.

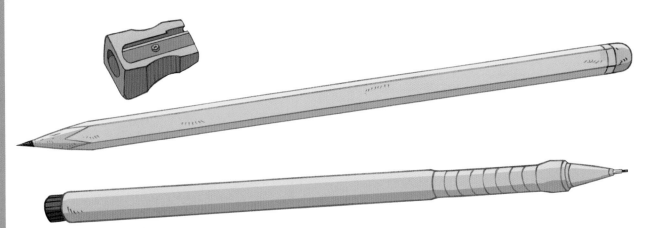

ADVANTAGES

① Even if you're new to drawing manga, chances are you've used pencils before so it's a medium you'll already have experience of.

② If drawn lightly, pencil marks can be removed with a soft eraser or putty rubber so shapes can be redrawn until they look right.

DISADVANTAGES

① Before committing to the final sheet, plan out your drawing on scrap paper first because if you make too many mistakes and then rub them out, this can leave permanent marks.

② Pencil gives an inconsistent line, depending on the pressure applied. This can make it tricky to maintain the shape and tone of a line, and is especially evident with soft pencils.

PENS

Pens can be divided into two major types: quill pens and ballpoint pens. Quill pens draw lines that have depth. The ballpoint pen gives clean, consistent lines and is much simpler to use.

If you look closely at a manga drawing, you will notice that the line thickness is often inconsistent, with lines thinning out at the end. To create this effect, simply control the pressure exerted on the pen. If used correctly, quill pens give nice, delicate lines and add a lot of depth to your illustration. Rotring rapidograph pens tend to be used for drafting purposes, but work really well for manga, too, so make sure that you use them! You don't have to worry about dipping the pen in the ink and the line texture will always be consistent.

ERASERS

You'll use this more than you probably want to, but remember, erasing mistakes is no bad thing! Residue from an eraser may spoil the overall tone effect if it remains on the paper, so be sure to keep your desktop clean. You may want to purchase a pen-type eraser for helping to get rid of small and narrow spots. Plastic erasers work very well as they don't lift the ink from your paper.

PRACTICE!!! No professional artist gets to the stage they're at without practicing.

QUICK TIP!

INK

After the picture is drawn, artists will often outline their work and paint in shadows with black Indian ink. The inking stage is important if you're doing a finished piece because it makes the lines look bolder and more suitable for print.

If you look through existing manga, you'll see that every panel is inked, giving the impression that pencils were never used in the first place.

There are three tools that you can use to apply ink to a picture—a pen and nib, a paintbrush, or a marker pen.

Many artists have days when they hate inking but they do it anyway. Use India ink, not only because it dries fairly quickly, but also because it is waterproof. An effective way to ink is to keep your strokes moving in the same direction and work as swiftly as possible. This way you will reduce the likelihood of unwelcome drips, splodges, and wrinkles. Using a blowdryer on your illustration also reduces wrinkles!

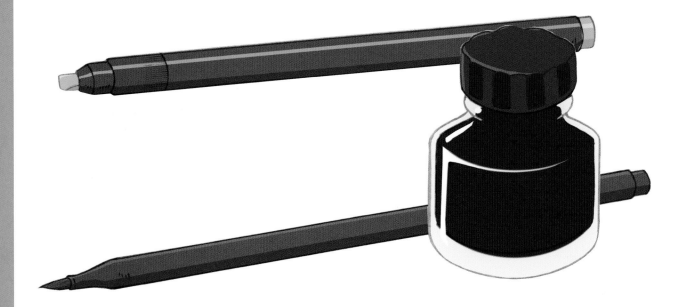

ADVANTAGES

① Inking a picture finalizes and strengthens the look of a line to make the image appear bold and ready for any coloring.

② Using varied line widths will make the picture appear dynamic and can give it a 3D effect.

DISADVANTAGES

① Ink is permanent, so whatever you put down on paper will stay there and cannot be removed without spoiling your drawing! Successful inking is a skilled process and requires a different technique to penciling. To get used to the medium, first practice by inking several sketches before applying ink to your finished piece.

WATERCOLOR

With the penciling complete, watercolor painting provides subtle tones and delicate pastel washes. Your drawing will have a loose and fluid feel rather than the bold and graphical effect you get with inking. Watercolors are very organic in the way they are applied and appear on paper, so suit a fine art style of working.

One renowned manga artist who regularly uses such coloring is Masamune Shirow. Although Shirow's early work was painted using traditional brushes, he has embraced computer technology and now does most of his coloring digitally.

Both methods are viable but working digitally gives you more control over the medium.

ADVANTAGES

① Delicate washes can be used and usually indicate femininity.
② Watercolor is quick and easy to apply.

DISADVANTAGES

① It is an unusual technique for manga and making it look effective takes practice. As it's rarely used in manga comics, watercolor is best suited for a stand-alone piece of work.
② Ordinary drawing paper is not suitable for watercolor painting. You will need thicker paper for the paints to be absorbed effectively without any running.

RULERS

Try to use your ruler as little as possible and practice drawing straight or curved lines without it instead. In the end, the only thing you'll really need your ruler for is drawing frames or borders around your comic, or for helping cut out your illustration. However, as you will no doubt use it initially here's a quick tip—those of you who have tried inking may have noticed that the ink tends to bleed or smear if you aren't careful. The easiest way to avoid this is to use a ruler with an elevated edge. You can raise your ruler simply by taping a coin (about the size of a quarter) to the underside. It works really well!

MATERIALS & TOOLS

VARIOUS

CELLULOIDS WITH ACRYLIC

Acetate is the thin plastic sheet that pictures are painted on for use in animation. When the acetate has an image on it, it is called a Celluloid or Cel for short. If you're keen on painting and using color, making cels might appeal. Although most manga is black and white, cel works are always in color and you can create manga images in the style of your favorite anime! Much of the art in this book lends itself well to the anime style so why not give it a try?

Acetate sheets are available from good art shops and come in various sizes and thicknesses and are affordable—much like paper. The size of the sheets used in professional productions are 10.3" x 9" for 4:3 ratio series or 13" x 9" for widescreen presentations. However, if you're planning to make individual pictures, just choose the size you want. To create a background for your cel, you can paint on a sheet of cartridge paper using watercolors.

ADVANTAGES

① Painting on acetate is the best way to emulate the 'anime look'—it's the way real cel animation is made.
② Once the outline is drawn on to the cel, it's easy to fill in the gaps with flat color.

DISADVANTAGES

① Take care when handling acetate and wear cotton gloves; even the cleanest fingers leave natural oils, which can slightly mark a surface.
② Painting in reverse may be a little confusing at first.

DIGITAL ART

Computers are being increasingly exploited as software/hardware becomes more advanced, cheaper, and readily available to home users. Digital art can now facilitate and combine drawing, inking, and coloring. You can draw effectively via the computer using a Graphics Tablet, and inking and coloring can be achieved through a variety of software packages. Digital artwork is vitally important in manga.

ADVANTAGES

① Paper, pencils, pens, and other traditional tools are not required.
② Mistakes can be easily erased and rapidly amended.
③ Different techniques and effects can be used to enhance the image—there are few limitations to what you can achieve with a still image.

DISADVANTAGES

① Buying a computer with the necessary hardware and software is very expensive but it becomes cost effective if you get a lot of use from it.
② The final product exists in a 'virtual world'—printing your work isn't as tactile as traditional artwork methods.

OTHER TOOLS

Of course, there are other tools and materials available to encourage your creativity, which is just as important as the technical stuff. Items such as paper, templates, and a light box can help you to achieve effective results not forgetting your workspace, which should be kept clean and tidy with everything you'll need to hand.

WORK AREA

Keep it clean and lean like a well-oiled machine. Poor rhyming aside, your workstation is vital to producing good illustrations. You must be comfortable (get a decent chair!) and have everything you need easily to hand. Avoid clutter, and ensure the area is well lit. You may also want to keep a number of books and other reference materials close to hand for quick and easy inspiration or guidance!

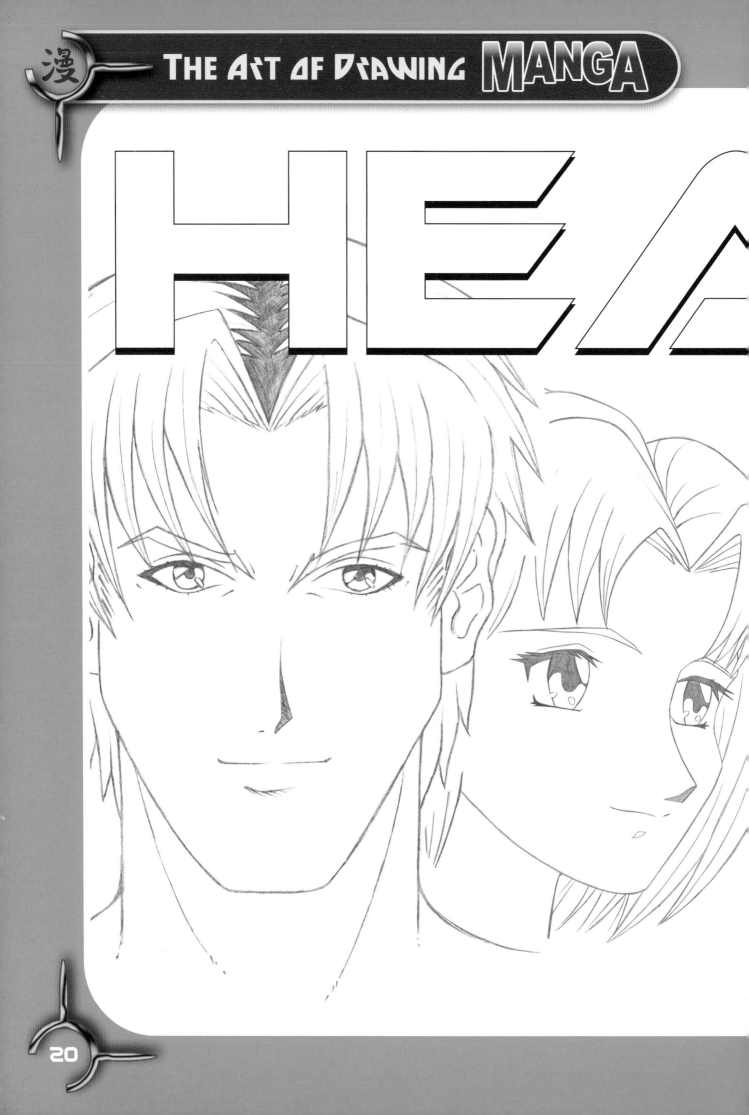

This is the initial focus of your manga character and the first thing that you'll start to draw—the head is key to your creation. Drawing the head can help you to define two main areas: proportion and pose. If you flick through this book, you'll see a particular style to the artwork that is typical of most manga—a standard body-sized representation. Other styles include Chibi (child-bodied) and Super Deform, abbreviated to SD (simplified miniature creations).

The head can be used as a tool to measure the proportions of the whole body so sketching this correctly is the first step to a competent-looking drawing. More information on this can be found within the 'Body' section but let's not get ahead of ourselves!

A head doesn't look much by itself. Only when the facial features are added does it begin to take on personality. However, you'll want to make the character appear dynamic and this is largely achieved by the pose, not only of the character's body but also the angle of the head.

When starting off, it's good to begin by practicing a lot of front-view angles to get the style and facial features right, then move on to an angle of the head and a side/profile angle, all of which have been illustrated in this section.

Good luck!

HEADS

Drawing the head (and the face to fit it!) is one of the most important, and often daunting, tasks of manga character illustration. In this section there are a number of step-by-step examples to help you become a confident creator of craniums, but to begin with, always bear these points in mind:

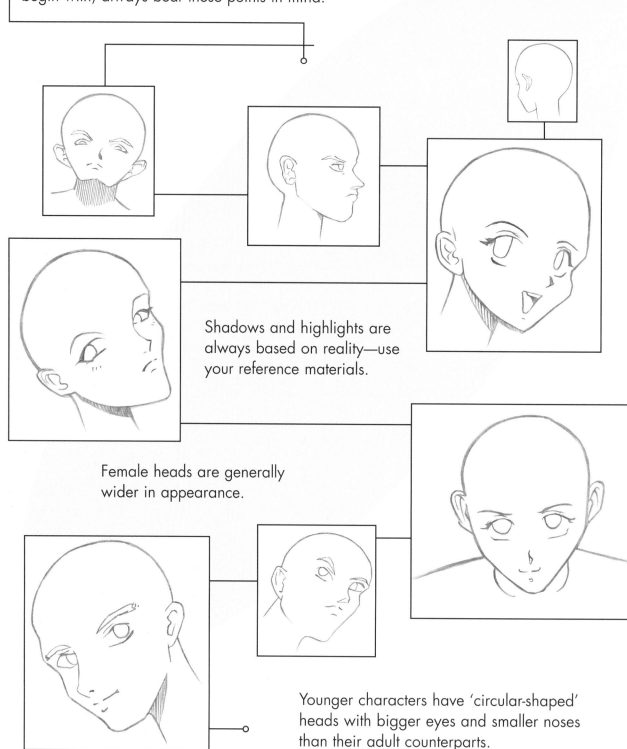

Shadows and highlights are always based on reality—use your reference materials.

Female heads are generally wider in appearance.

Younger characters have 'circular-shaped' heads with bigger eyes and smaller noses than their adult counterparts.

STYLES HEADS

The shape of the head and the facial features differ, depending on the age and personality of the character.

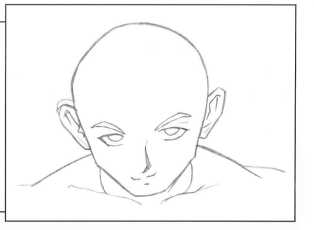

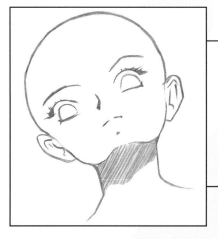

Female eyes are drawn bigger so they look more appealing.

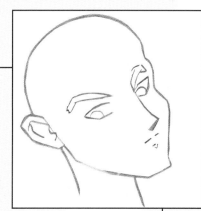

Always keep your guide lines tight—they aren't part of the final illustration but are essential in giving your creation proportion and symmetry.

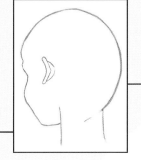

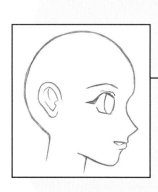

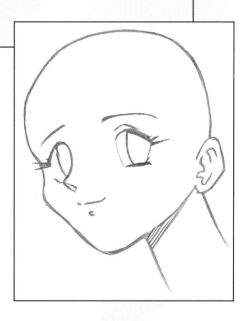

When drafting out your head illustration, press lightly or use lighter pencils so mistakes can be easily erased.

HEADS

MALE FRONT VIEW

STEP 1 ▶

All heads start by simply drawing a circle with a center line through it. You do not need to draw a perfect circle. Note that these lines are guide lines and are not all supposed to be left on your final drawing so remember to draw them lightly so that they can be erased later.

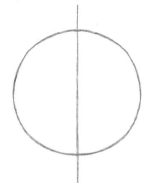

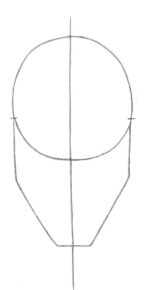

◀ STEP 2

Male faces are generally longer and more angular than female faces. Draw two parallel vertical lines downwards from the side edges of the circle. Slope the lines inwards to create the jaw.

STEP 3 ▶

Fill out the proportions of the face by adding in guide lines. Near the bottom of the circle you can see the eye and eyebrow lines which are spaced apart equally. Mark in where the beginning and end of each eye goes. Remember to keep things symmetrical by using the central guide line to help you. Draw a square down from the center of the bottom of the circle. The base of this square will mark where the nose ends. Draw two equally spaced horizontal guides below the square—these are the lip guides. I've also marked in where the bottoms of the ears go—just above the slope of the jaw.

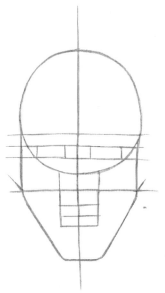

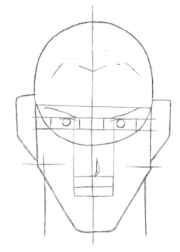

◀ STEP 4

Add in some facial details—eyeballs, eyebrows, and a nose. The nose is represented by a shadow right down the central line. Draw boxes for where the ears will go—the top of the boxes are just above the eyebrow. Neck lines should fall parallel from the jaw. The neck should be just a bit narrower than the width of the head. Draw in the hairline on the forehead.

STEP 5 ▶

Define the eyes inside their guide boxes. The nose shadow line goes up to the bottom of the circle. The mouth and bottom lip are added, then the guide lines removed. Add detail to the insides of the ears and provide a rough idea of where the hair will go. Hair can't grow from below the hair-line. Add lines where the neck tendons go.

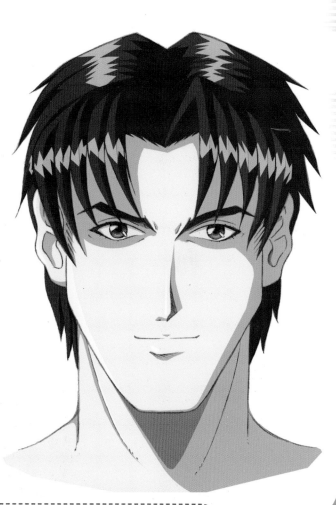

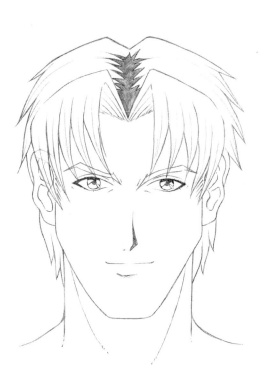

STEP 6 ▲

Add the finishing details and make your final lines bolder, erase the guide lines, and clean up the image.

Now it's all ready to color in!

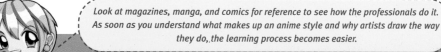

Look at magazines, manga, and comics for reference to see how the professionals do it. As soon as you understand what makes up an anime style and why artists draw the way they do, the learning process becomes easier.

QUICK TIP!

HEADS

MALE 3/4 VIEW

STEP 1 ▶

Start with a circle. Because the head is at an angle, the central line curves and is aligned left in the direction in which the head will be facing. The chin line at the bottom is drawn at a slant.

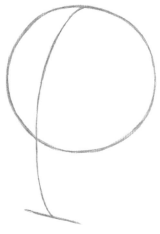

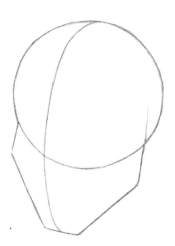

◀ STEP 2

On the left, draw the cheekbone as a diagonal line extending from the circle. Join this to the bottom of the jaw. Draw the cheekbone and jaw line as shown on the diagram.

STEP 3 ▶

Draw eye lines parallel to the chin. The top eye line joins where the circle meets the cheek line.

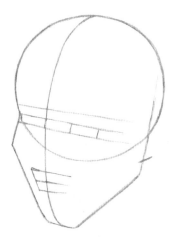

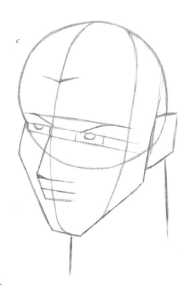

◀ STEP 4

To create the nose, extend the line down from the central line to the corner of the guide box. Create a box for the ear. The first neck line comes down from near the center of the chin, the second comes down from the ear.

STEP 5 ▶

Add details to the eyes, mouth, and ears. Rough out where the hair will go and remove the guide lines.

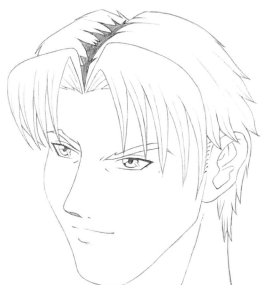

STEP 6 ▲

Add in the finishing details and make your final lines bolder. Erase the guide lines and clean up the image.

Now it's all ready to color in!

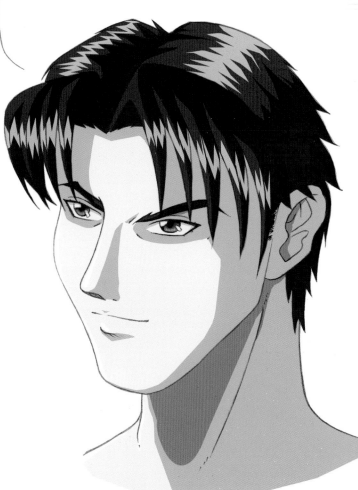

STEP 1 ▶

Start by drawing a circle—it doesn't have to be perfectly round. Intersect the circle with two lines towards the bottom right-hand area; one line horizontal, the other vertical. As these are guide lines only, draw them in lightly so they can be erased later.

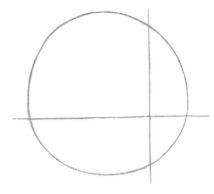

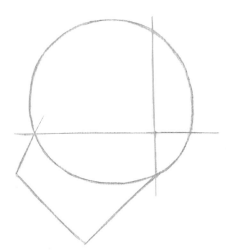

◀ STEP 2

Draw a box diagonally starting from where the intersecting guides meet the bottom of the circle. This box is the jaw line guide.

STEP 3 ▶

Add eye line guides—the top guide runs horizontal and parallel to the existing intersecting line. Add in the eye, which is triangle-shaped. Add guides for the bottom of the nose, mouth, and bottom lip. Also note where the bottom of the ear starts.

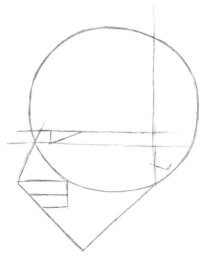

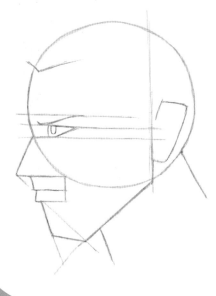

◀ STEP 4

Add in some facial details such as the eyeball and eyebrow. Begin a vertical guide line and box in the ear. The biggest step is to chisel out the mouth and chin. Add in the neck lines and indicate the top of the hairline.

STEP 5 ▶

Add more facial details and round off the mouth, lips, and chin. Rough out where the hair will be. Hair will grow from above the hairline guide. Add a neck tendon in a diagonal line.

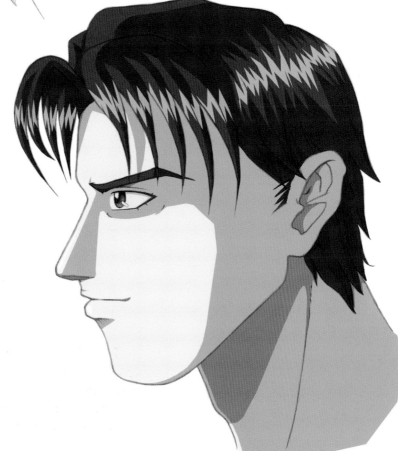

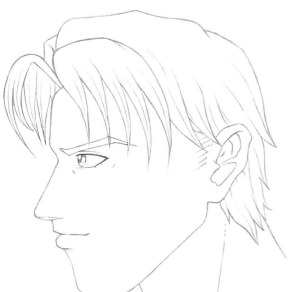

STEP 6 ▲

Add the finishing details and solidify your final lines. Erase the guide lines and clean up the image.

Now it's all ready to color in!

FEMALE FRONT VIEW HEADS

STEP 1 ▶

Remember that all heads start by drawing a circle with a central line. It is not necessary to draw a perfect circle. As before, remember to draw guide lines lightly so that they can be erased later.

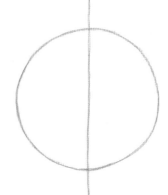

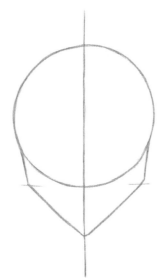

◀ STEP 2

Female faces are generally rounder, smaller, and a lot less angular than male faces. Draw two short parallel vertical lines downwards from the side edges of the circle. Slope the lines sharply inwards to create a smaller jaw.

STEP 3 ▶

Fill out the proportions of the face by adding in more guide lines. Mark in where each eye goes—note these will be bigger than male eyes. Remember to keep things symmetrical by using the central guide line to help you. Draw a square down from the center of the bottom of the circle. This square will form the mouth.

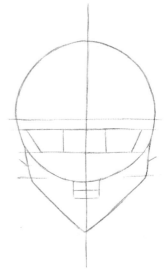

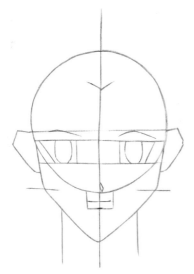

◀ STEP 4

Add in some facial details. As you would expect, features such as the nose should be a lot less prominent. Draw in the outline of the ears—they will help you shape the hair at a later stage. Neck lines should fall parallel from the jaw and equidistant from the central line. The neck should be just a bit narrower than the width of the head. Draw in a small 'v' to mark the hairline on the forehead.

STEP 5 ▶

Define the eyes inside their guide boxes. The eyes should be big and bold as this is a strong feature of manga female characters. Add detailing to the insides of the ears and begin to sketch in the hair around the shape of the face. Turn the neck lines into a curved shape to suggest a more graceful female form.

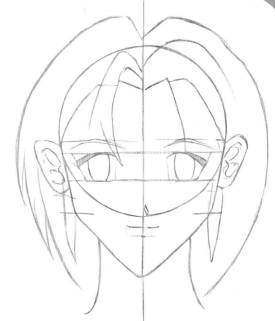

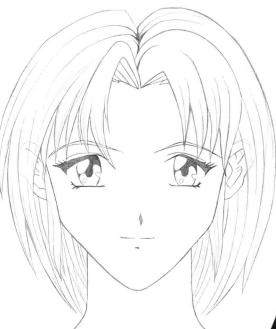

STEP 6 ▲

Add the finishing details and solidify your final lines. Put life into the eyes by carefully shading in the pupils. These are your character's most prominent feature so work hard to get it right. Erase guide lines and clean up the image.

Now it's all ready to color in!

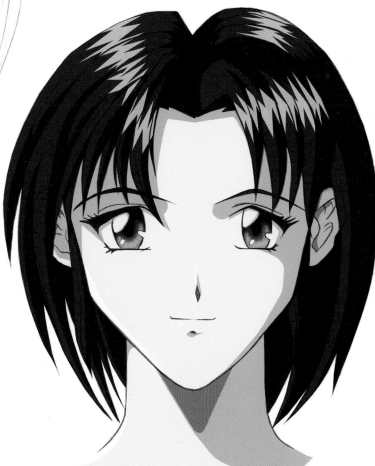

HEADS

FEMALE 3/4 VIEW

STEP 1 ▶

Start with a circle. Because the head is at an angle, the central line curves and is aligned left in the direction the head will be facing. The bottom chin line is drawn at a slant.

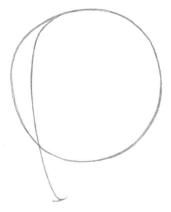

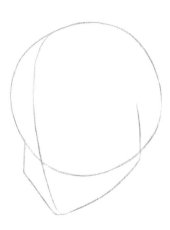

◀ STEP 2

On the left, draw the cheekbone as a diagonal line extending from the circle. Join this to the bottom of the jaw or chin. Draw the cheekbone and jaw line as shown on the diagram.

STEP 3 ▶

Draw the eye lines parallel to the chin. The top eye line meets where the circle meets the cheek line.

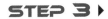

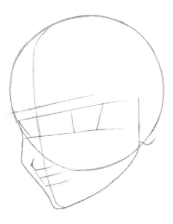

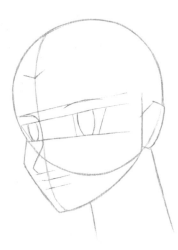

◀ STEP 4

Extend the line down from the central line to the corner of the guide box for the nose. Create a box for the ear. The first neck line comes down from near the center of the chin; the second comes down from the ear.

STEP 5 ▶

Add details to the eyes, mouth, and ears. Rough out where the hair will go. Remove the guide lines.

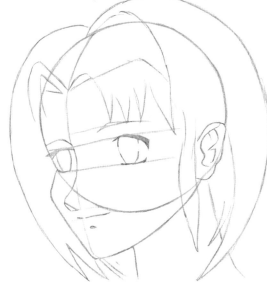

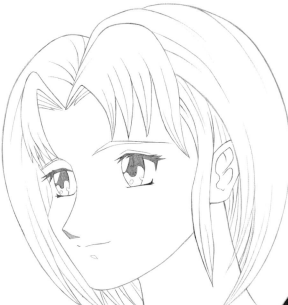

STEP 6 ▲

Add the finishing details and solidify your final lines. Erase any guide lines and clean up the image.

Now it's all ready to color in!

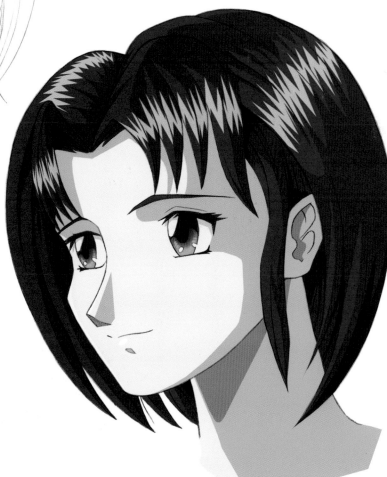

FEMALE SIDE VIEW *HEADS*

STEP 1 ▶

Start by drawing a circle. It doesn't have to be perfectly round. Intersect the circle with two lines towards the bottom right-hand area—one line horizontal, the other vertical. As these are guide lines only, draw them in lightly so they can later be erased.

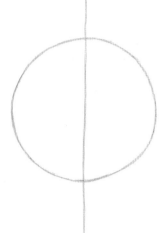

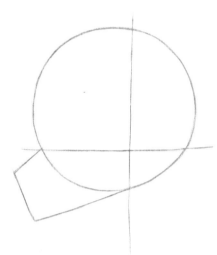

◀ STEP 2

Draw a box diagonally from where the intersect guides meet the bottom of the circle. This box is the jawline guide.

STEP 3 ▶

Add in the eye line guides—the top guide runs horizontal and parallel to the existing intersecting line. Add in the triangle-shaped eye. Space the horizontal lines equally and add as guides for the bottom of the nose, mouth, and bottom lip. Also add in the point where the bottom of the ear starts.

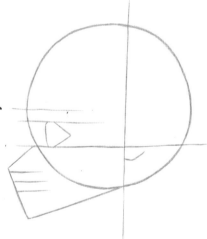

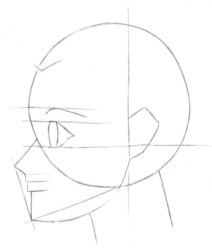

◀ STEP 4

Add in some facial details—the eyeball and the eyebrow. Begin the vertical guide, box in the ear. The biggest step is chiseling out the mouth and chin. Add in the neck lines and where the top of the hairline is.

STEP 5 ▶

Define more facial details—the eye, eyebrow, the inside of the ear. Round off the mouth, lips, and chin. Rough out where the hair will be. Hair will grow from above the hairline guide. Add the neck tendon in as a diagonal line.

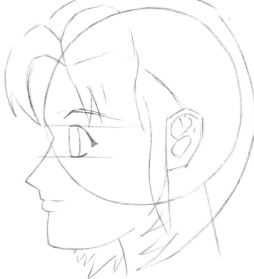

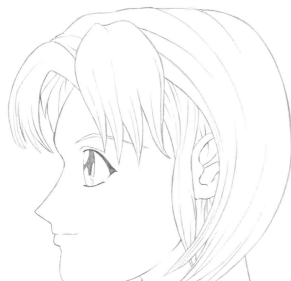

STEP 6 ▲

Add the finishing details and solidify your final lines. Erase the guide lines and clean up the image.

Now it's all ready to color in!

Do your drawings look a mess after constant erasing? Try pressing your pencil more lightly on the paper and use a pencil like a 2H. When you are happy with your work, you can go over the lines with a darker pencil (B) or ink if you like.

QUICK TIP!

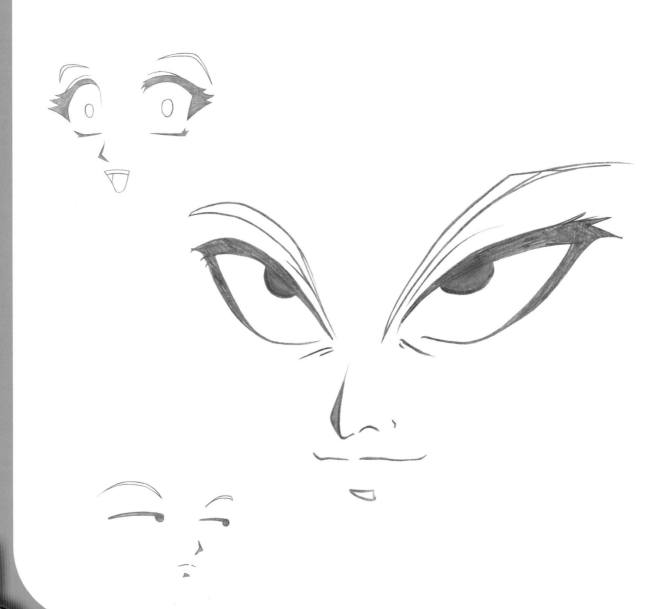

Once the head is drawn, you naturally need to add a face and this is the really fun part! It is important to pay attention to detail here because the face will give your character personality and a lot will depend on the size and shape of the features. Drawing the face allows you to show whether a character is male or female, young or old, or even if they are good or evil.

When we see manga faces, we can immediately tell them apart from real-life portraits and other cartoon styles because of the particular techniques used to create them. Consider what you would have to think about when drawing a life-like picture of a person's face. There are a lot of details that we see including the size and shape of the features, bone structure, and textures such as skin tone.

To 'animize' a face, we use a degree of simplification and suggestion—this is true for all cartoon styles but the application is unique in manga.

Manga faces are often idyllic and beautiful; they will have a flat, smooth skin tone (wrinkles are only used to represent very old people) and simplified features. The eyes are often large and reflect a lot of light and the nose and mouth are represented by simple dashes or curves. As easy as this might sound, there are right and wrong ways to draw features as outlined in this section.

FACES

EYES—STYLES

EYES

It's time to get going on the face so I'll begin with the eyes which are the hardest part to master I think. The hair comes a close second!

Why is drawing eyes the hardest thing to master? Primarily because the eyes play such an important role in expressing the character of your creation. Not only do you have to make sure that the eyes are balanced, you also have to draw the eyes so that they show the emotion inside the character. Hair might be difficult to draw but mastering it isn't hard when compared to doing eyes.

There are many different types of eyes (and eyebrows!), and I've included a few examples to give you some ideas. Eyes can take many different shapes and sizes, and they may appear fairly easy to draw—they are, but only when done badly!

Looking at the range of samples that I've provided, do you think you can easily spot the different male and female eyes?

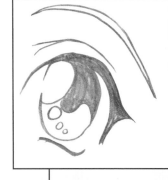

'*Jagged*' eyebrows are used for characters that have an exceptional or exaggerated personality. Many villains have these eyebrows but you would very rarely see them used for female characters!

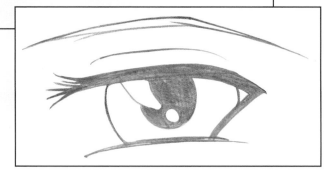

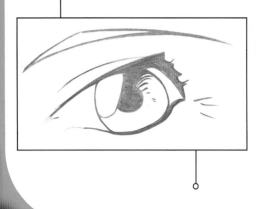

'*Streamlined*' eyebrows are the most commonly used. They can be a straight line, a 'hill', or a small wave.

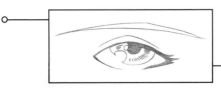

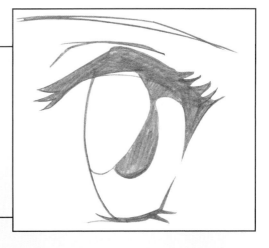

When drawing male eyes, male eyebrows are created, eyelashes are omitted, and the eyes are usually smaller than that of female characters.

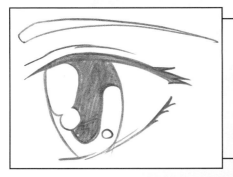

Eyes can be hooded, wide-open, or can glint in the light—vital for drawing character emotion.

As different characters have different personalities, these rules aren't written in stone and you'll need to break the rules occasionally. For example, a strong, adventurous woman may have thicker eyebrows.

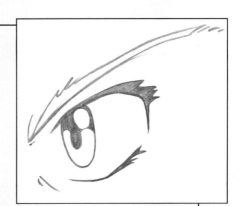

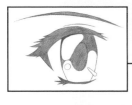

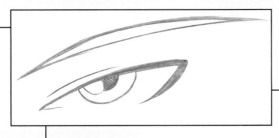

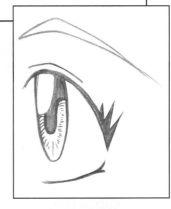

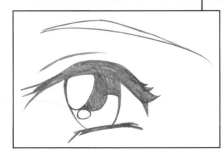

Women tend to have thin eyebrows. The eyelashes are thicker and the eyes are bigger in comparison to a male.

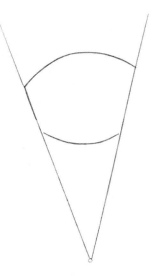

◀ STEP 1

Some people prefer to start with a ball, but I think this approach produces a better eye. Begin by drawing a large off-center 'v' and, somewhere around the middle, draw two opposing curved lines. This represents the orb of the eye and helps with the general placement of the eye in the skull.

STEP 2 ▶

Here's where most budding artists can go wrong. The lids wrap around the contour of the orb. Imagine stretching a sheet of rubber over a cue ball. The eyelid hugs the curvature of the eye.

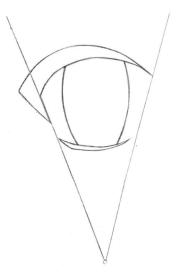

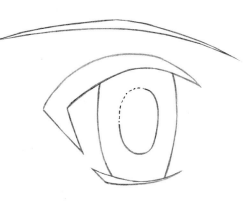

◀ STEP 3

The eye in a relaxed state hides some of the iris behind the lids. Notice how the iris takes up most of the surface area of the orb. This really only occurs in manga. Also sketch in your eyebrow—as you may have already guessed, this is a female eye so the eyebrow is thin. You've now got the basics of your eye in place.

STEP 4 ▶

It starts getting more complicated as you add the details that will set your eyes apart from other illustrators! Have a look at the shapes I've sketched—they won't make much sense at the moment but all will be revealed as we start to color in the eye. It is all about the reflection of light and the role of shadows.

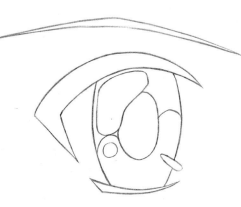

STEP 5 ▶

Up until now, the eye has been left fairly plain. Flesh out the eyelids with some heavy-duty, fluttering lashes. This adds weight to the eye so it's not simply floating around on the face. It also draws the viewer's attention. The thickness of the lashes will depend on the character you are creating. Obviously male characters won't have this trait and younger females should have a thinner line. This eye is right for the sexy adult female. Also note the small 'x' in certain areas—this is to show where I'm going to add solid color.

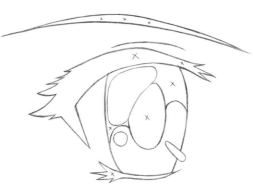

◀ STEP 6

A 'specular' is the reflection of light on a reflective surface. The placement of the specular on the eye should be indicative of the local source of light. If the light is coming from the upper left, the specular should be on the upper left of the iris. In this case, the light enters the eye from the upper left and exists through the lower right. In manga, speculars are also used to add emotion to a character. For example, sparkling light brings life to happy eyes.

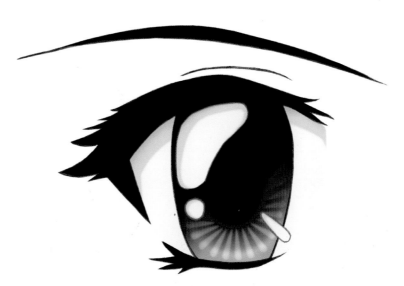

Here's the finished eye—better get on with the other one!

NOSES & MOUTHS

Manga-style noses and mouths are pretty straightforward, so rather than taking you through various types step-by-step, I have included a number of examples to give you an idea of the styles that you can use.

The basic style for nose and mouth consists of three simple steps: a wedge for the nose; a long, thin line for the mouth; and a shorter line to define the lower lip (although this lower line is not always included). With frontal views, you can get away with using very few lines to define the nose and mouth. The size and shape of each feature varies with each character.

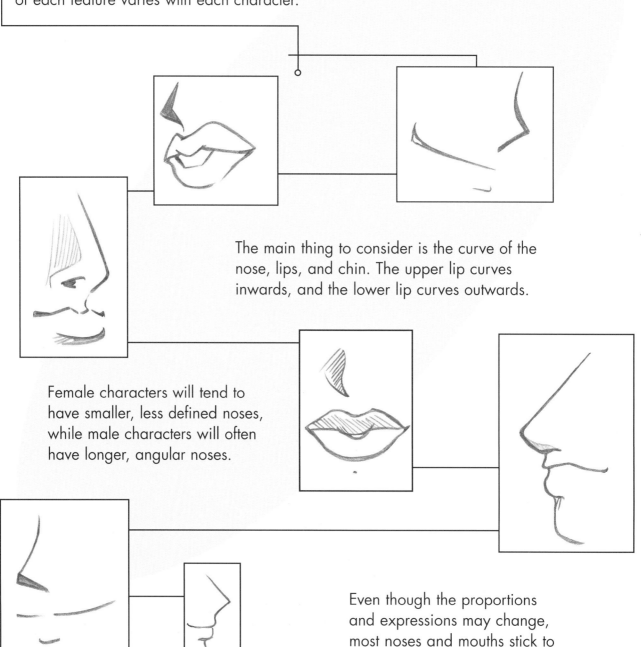

The main thing to consider is the curve of the nose, lips, and chin. The upper lip curves inwards, and the lower lip curves outwards.

Female characters will tend to have smaller, less defined noses, while male characters will often have longer, angular noses.

Even though the proportions and expressions may change, most noses and mouths stick to the same basic shapes.

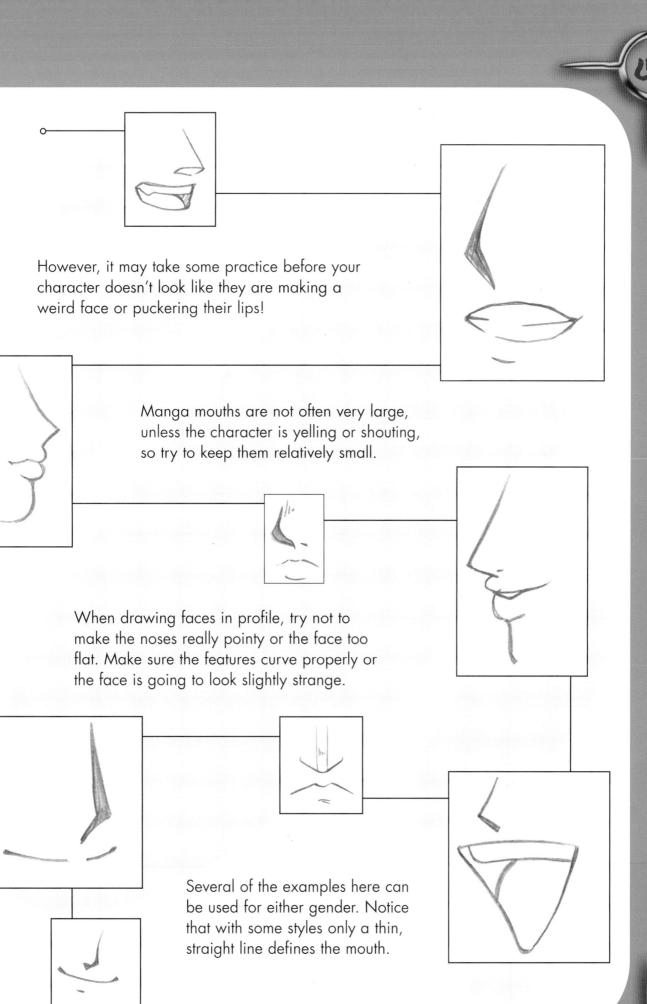

However, it may take some practice before your character doesn't look like they are making a weird face or puckering their lips!

Manga mouths are not often very large, unless the character is yelling or shouting, so try to keep them relatively small.

When drawing faces in profile, try not to make the noses really pointy or the face too flat. Make sure the features curve properly or the face is going to look slightly strange.

Several of the examples here can be used for either gender. Notice that with some styles only a thin, straight line defines the mouth.

EXPRESSIONS

This is all pretty much self-explanatory—you put an expression on a face to give the viewer as clear an idea as possible of the emotion that your character is expressing or experiencing.

On the following pages, you will find a number of expressions that will cover most of the basic emotions that your characters are likely to feel. Try drawing the expressions one by one—you'll soon get a feel for placement of the various features and how different expressions can radically change your character's look!

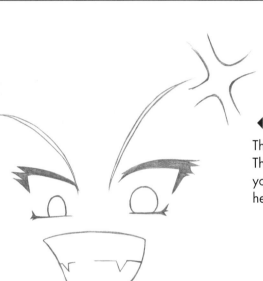

◀ ANGRY

This is the face of someone who is really, really mad! The eyebrows come down sharply, the pupils shrink, and you get a pulsating vein on the forehead. Fanged teeth help convey the emotion!

ANNOYED ▶

The pupils are still small but there are no popping veins or fanged teeth! The mouth goes up in an upside-down lopsided 'u'. The eyebrows still come down but not as far.

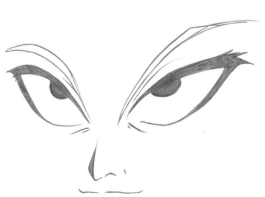

◀ EVIL

One of my favorites! The eyebrows are drawn thinly and look sharp, pointing downwards. Dark eyelids obscure the iris and pupils giving a hooded look. The nose is small and pointed and the mouth is thin and slightly upturned at each corner suggesting a sly smile.

FRIENDLY ▶

The eyebrows are up. A thin line follows the upper curve of the eye to convey a relaxed state. The mouth is a sideways 'D'.

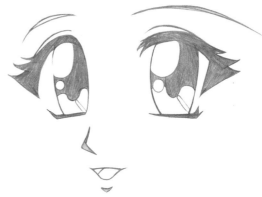

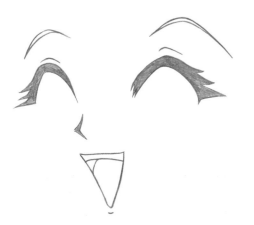

◀ HAPPY

The eyes are shut from laughing or smiling. The mouth is a huge, sideways 'D' and the eyebrows are up. You could even add some blush to the cheeks if you wanted to make really sure your character looks happy.

SAD ▶

The eyebrows are up, the mouth is a downturned line, and the open eyes have more sparkles in them to convey a wet look. Tears are visible in the corners of each eye.

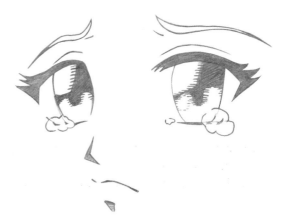

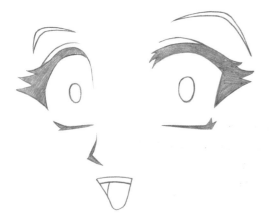

◀ SURPRISE

The eyebrows are up! The eyes are very wide open but the pupils are small. The mouth takes the shape of a sort of lopsided 'o'.

Having trouble with drawing faces and expressions? Try keeping a little mirror with you as you draw. Just pull the type of face you're after and draw what you see!

QUICK TiP!

HAIR

Hair can be particularly difficult to draw but, unfortunately, it's just something that takes practice and cannot be taught with a simple step-by-step. The different styles are just too numerous to cover in this book!

Depending on the style, manga hair can be very complex. However, if you break it down into its basic components, the process of drawing manga hair becomes a little simpler.

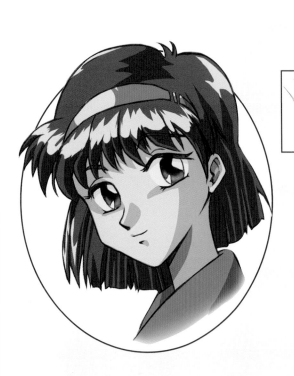

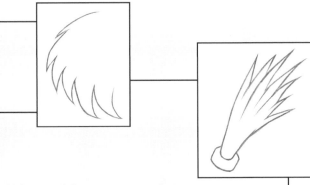

Like real hair, manga hair is composed of many strands. However, rather than drawing each individual strand, the hair is often drawn in various sized or shaped clumps.

You can either make the hair very detailed or very simple, depending on how many individual strands you draw.

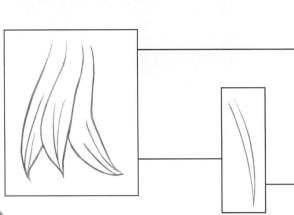

You can create some really interesting hair by having it twist and turn all over the page.

Keep in mind that you can make the hair as detailed as you like—just keep adding more strands.

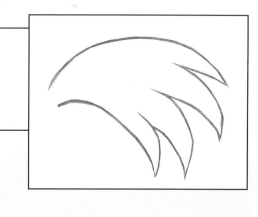

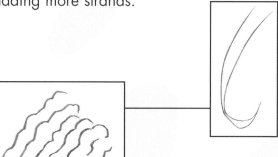

Once you know how to draw each strand or clump of hair, you can start putting them together to form something that closely resembles 'anime' hair.

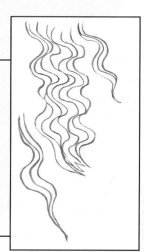

Similar shapes generally persist across different types of hairstyle. Making one line curve out more than another on each strand can really help flesh it out.

The size and shape of each strand gives the hair different character; the strands can be long and thin, thick and curvy, or sharp and spiky.

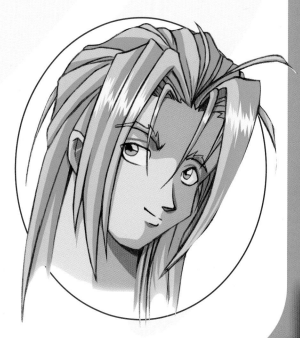

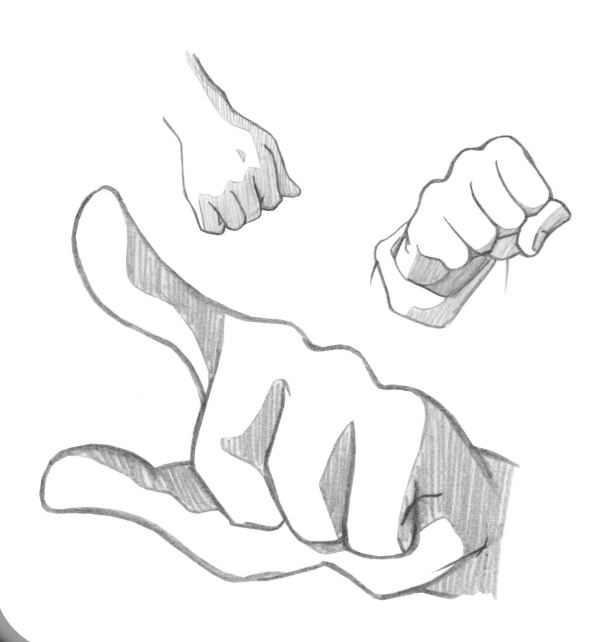

Here I will be talking about drawing hands. Hands are absolutely vital to the overall look of your finished artwork. Many people treat them as an afterthought and yet think about how much you use your hands every day. So, take your time to get the basics right to ensure the hands are every bit as good as other aspects of your character studies.

The basic form and procedure for creating hands is similar to that of figure drawing. You break the overall shape down to simpler sizes, and then connect them all together. With good composition, you can draw hands from any possible angle.

When drawing hands, try not to think of detailed contours but rather about the composition of the hand structure broken down into simpler terms. Remember how many different aspects there are to a hand—in effect, it's a torso with five limbs!

It can also take on many different shapes and forms, all adding particular aspects to your character and the overall composition. A clenched fist, a wave, a thumbs-up—they all project very different stories and are vital to enforcing the image of your character's actions.

However, if you're still struggling with the complexities of hands after going through the advice in this section, don't panic! The great thing about manga is that you are encouraged to be creative with your drawings. If you can't draw a human hand then make it something else!!!

HANDS

STYLES

HANDS

Hands can be a nightmare for most artists. It's hard to create a hand in basic shapes so break it up into major forms and really pay attention to where it folds and bends.

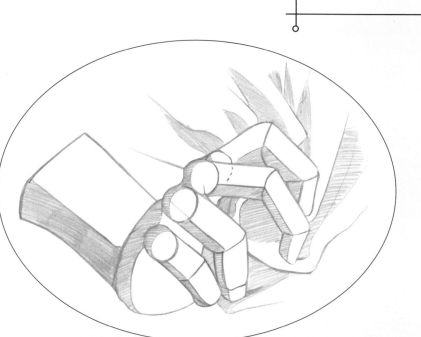

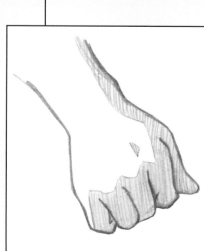

Have a look at the various examples to get a feel for how hands are constructed.

The hand is a bit like a shovel. The palm gives you the lines you need to see where it bends.

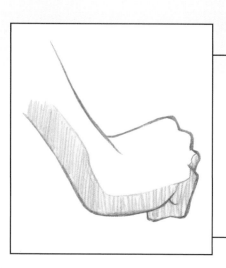

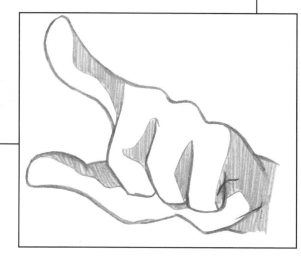

The thumb side of the palm pivots from the center.

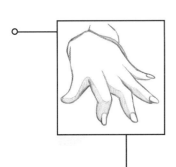

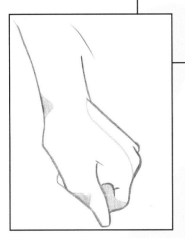

Never make the hand a flat wedge. It curves and follows the contours of the lines on the palm.

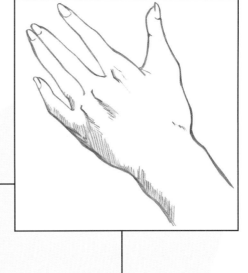

It is essential to recognize how the joints in the fingers and wrist work if you are to draw an accurate representation of a hand in action.

Even when drawing a hand from the rear, pay attention to the fold lines on the palm. This will help you draw more natural positions for the thumb and fingers.

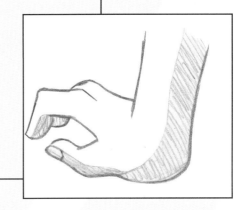

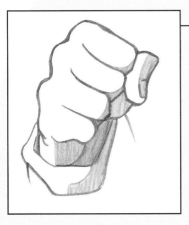

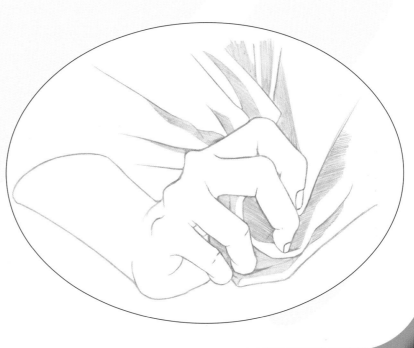

Notice how shading is vital for highlighting the actions that hands are carrying out.

HANDS

STEP-BY-STEP

◀ STEP 1

Start with a simple orb. Make sure it doesn't take up too much room on the paper as you will need to draw quite a lot around it. I know it seems strange starting out with a circle but, trust me, it will all come together!

STEP 2 ▶

Now draw a gently curving line across the bottom half of the orb—this will provide a guide to the middle of the outstretched palm. Also add a simple curve around three-quarters of the orb as this marks the end of the fingers.

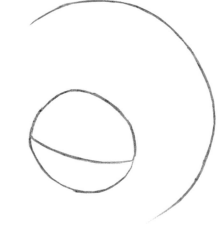

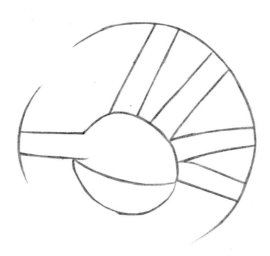

◀ STEP 3

At this stage, it's time to add in the fingers and thumb as simple tubes. As you can see, it's starting to look like a hand already! Notice how the thumb projects from the point where the palm line touches the circle.

STEP 4 ▶

Now that it's beginning to look like a hand, start shaping the overall form. Erase your initial guide lines.

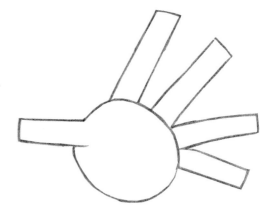

STEP 5 ▶

Round off the fingers and thumb at both ends. You now have fingers with tips and a clear indication of where the fingers and thumb join the palm. Square off the original circle to give the hand its recognizable flatter, more angular shape.

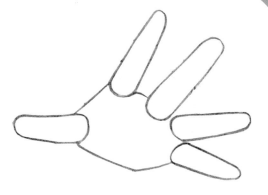

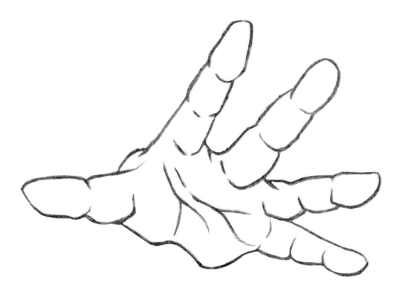

◀ STEP 6

Add in all the details to really bring your hand to life. The best way to do this is to look at your own hand. Note the use of simple lines to create effective wrinkles and creases that all add to the realistic look of the hand.

STEP 7 ▶

Color puts the icing on the cake. Use careful but simple shading to bring out the tones of the hand and emphasize its position and action.

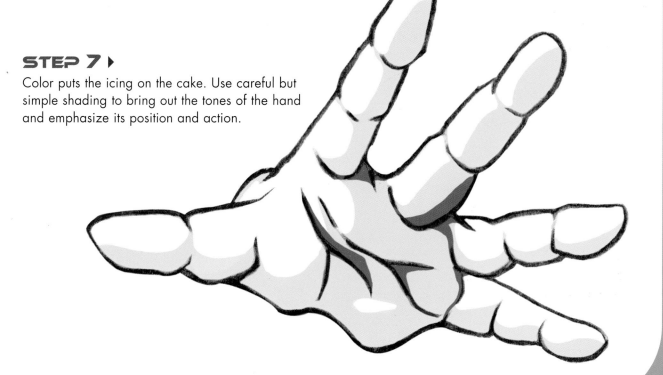

FIGU

Having looked at constructing the head and face, we can begin to address the body. Again, this is a very important stage where we define the character's appearance in terms of size and muscle structure, proportion, and chosen style.

What are the differences between manga proportions and real-life proportions? Many 'animanga' characters, especially the main heroes, are teenagers or young adults—the reason is because this media is largely marketed at the age group that identifies with them most. Such characters are often slim and athletic with longer legs than real-life individuals.

The character's pose is depicted by the body and is one of the most descriptive parts of the picture. Think about the angles you could use to make the picture visually interesting and what body language can suggest to help explain a character's actions and movement. You should think of yourself as a film director who chooses specific camera angles and tells the actors how you want them to move and act in a given situation. This analogy is worth using again when we come to look at creating manga layouts and panels.

Whether someone is in a dynamic action shot or slouching in a chair, this has a direct effect on the composition of the picture and gives us information about that character's actions, personality, and the overall mood of the scene. Don't think too deeply about the construction of your picture; these are just considerations that should be in the back of your mind—after some practice, you'll come up with ingenious ideas for how to get the most from your poses.

BASIC SHAPES

Look at the shapes below. Seem simple, huh? Well, practice them until you can't draw anymore, and then practice some more, because these shapes form the cornerstone of all the figurework you are ever likely to do in manga.

Whenever you're bored, doodle these shapes and practice shading and developing them, maybe even linking the shapes together. Over the next few pages, you'll discover just why they are so important.

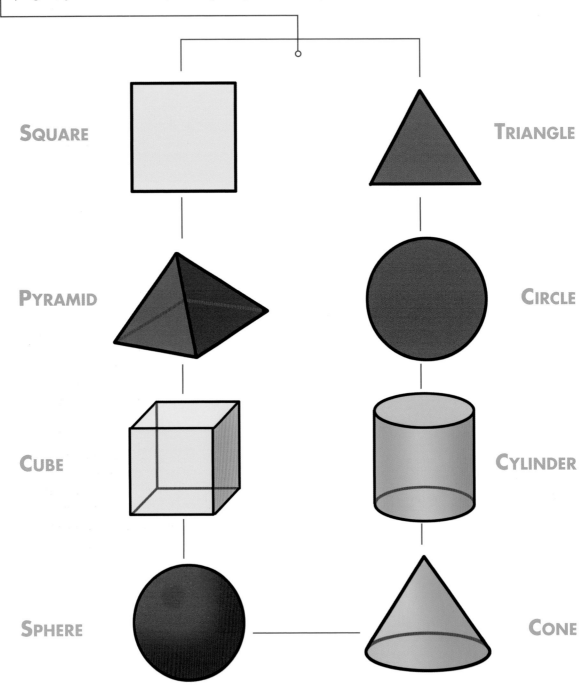

SQUARE

TRIANGLE

PYRAMID

CIRCLE

CUBE

CYLINDER

SPHERE

CONE

FIGURES

BASIC SHAPES

PROPORTIONS

Average Manga Proportions

Note: The body is in proportion with the size of the
eyes and the head.

BODY HEIGHT

6½–7½ head heights high.

HEAD

3½ eye heights high by
4–4½ eye widths wide.

EYES

A little more than one
eye width apart.

MOUTH

About one eye height
above the chin.

NECK

Three eye widths wide.

SHOULDERS

Twice as wide as the head; one
eye height below the chin.

UPPER ARM

Slightly less than the width of
the neck—the distance from the
elbow to the armpit is one
head height.

LOWER ARM

Distance from the wrist to
the elbow is slightly more
than one head height
(same as length of foot).

HAND

About ¾ head height long.

CHEST/HIGH BUST

Same width as height of head
(distance between armpits).

BUST

Fullest point falls one head
height below the chin.
The breasts are three
eye widths wide.

WAIST

Falls one eye height below the
elbow, slightly less than
the width of the chest.

HIPS

1¾ –2 times the
width of the head.

LEGS

About half the overall height.

UPPER LEG (THIGH)

Almost as wide as the head.

KNEE

Two head heights above
the bottom of the foot.

LOWER LEG (CALF)

Same as the neck.

FOOT

Its length is slightly more than
the height of the head.

*These average proportions
will work for either a male
or female character. For a
male character, you may
wish to slightly expand the
width of the chest and
make the hips 1¾ the
width of the head. For a
female character, keep the
width of the chest the same
as the height of the head
but make the hips two
head widths wide.*

FIGURES PROPORTIONS

FEMALE FRONT VIEW FIGURES

STEP 1 ▸

All right, now that we've gone over some of the major areas in detail, let's put them all together and make a full body pose. When drawing your subject, you can either begin with the preliminary ovals and circles, or you can go straight to the final draft, whichever you are most comfortable with. If you are using circles and ovals, then you will notice that the main body (torso and pelvis) is composed of a basic triangular shape which curves inwards towards the stomach.

◂ STEP 2

Make sure that this shape is aligned along the central guide line, as shown in the head. This guide line in the head can basically be continued to form the spine of the character and will determine her pose. Notice that the central line curves a little to the right on the pelvis because her weight is shifted and her right hip sticks out slightly. This makes the pose a little more interesting than if her weight were evenly balanced.

STEP 3 ▶

The body can be divided in half equally if the central line in the head is continued down the length of the body. Use this as a general reference when determining how long the legs should be in proportion with the rest of the body yet, often in manga, the length of the legs is exaggerated, for both males and females, and looks just fine. When drawing the midsection, remember to try to keep the hourglass shape of the figure.

◀ STEP 4

Female manga characters will generally have thin shoulders, a thin stomach, and a somewhat rounded waist. Take care to make the curves look natural, unless you are really good at figure drawing and can exaggerate the proportions. Begin by adding clothes (as many or as little as you like) to cover up those areas that can be particularly hard to draw. It is very difficult to draw the female bust, for example, so use clothing to make this easier and hide any parts of the figure you are not happy with.

STEP 5 ▶

It's time to add in the final details—nails to the fingers, detail to the eyes and ears, and think carefully about creases and shading on the clothes.

◀ **STEP 6**

Remember to make the eyes big and almond-shaped. Notice how adding in eyelashes opens up the eyes even more, and helps accentuate the femininity of the face.

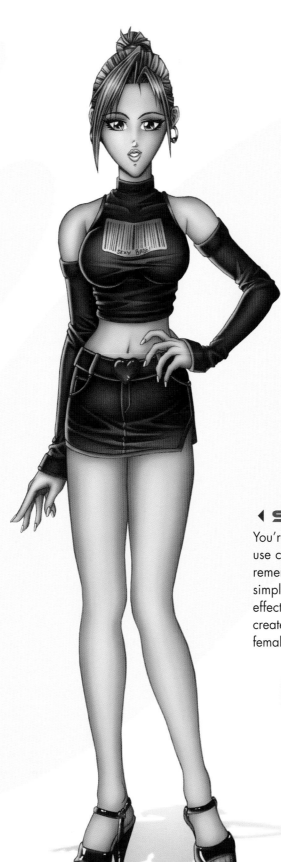

◄ **STEP 7**

You're now ready to use color but remember to keep it simple for maximum effect! You've just created your first female manga figure.

MALE FRONT VIEW · **FIGURES**

STEP 1 ▶

Start building your figure using basic shapes. Look at the arms. They consist of three basic sections: the upper arm, the forearm, and the hand. Each can be represented by preliminary sketches using oval shapes. I know some people don't like using shapes to draw a figure: you don't have to sketch arms in this way; it is just one possible way of going about it.

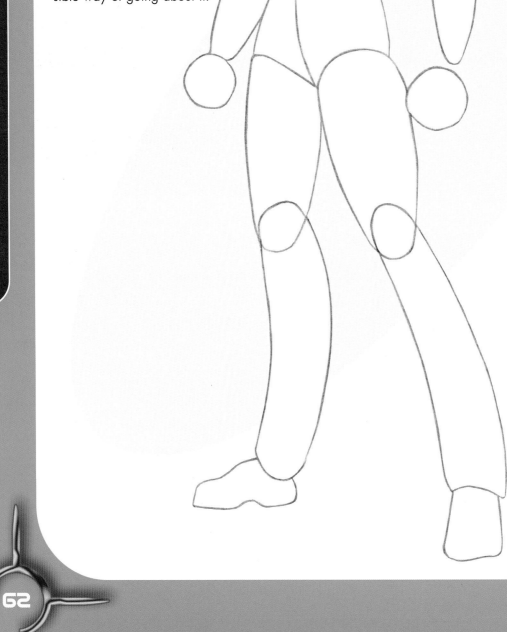

◀ STEP 2

Some recommend using cylinders, but it's better to use flat ovals because they more closely match the shape of the arm. If the arms are held loosely at the sides as here, the hands should come down to the middle of the thigh. The elbows should be at about waist length.

STEP 3 ▶

Draw in some hair and add the outlines of the costume. Note how the male figure does not have sloping shoulders like female characters. The body tends to be made up of solid blocks or slabs of shape rather than smaller, curved shapes. Drawing the hands as clenched fists suggests strength and power in the pose.

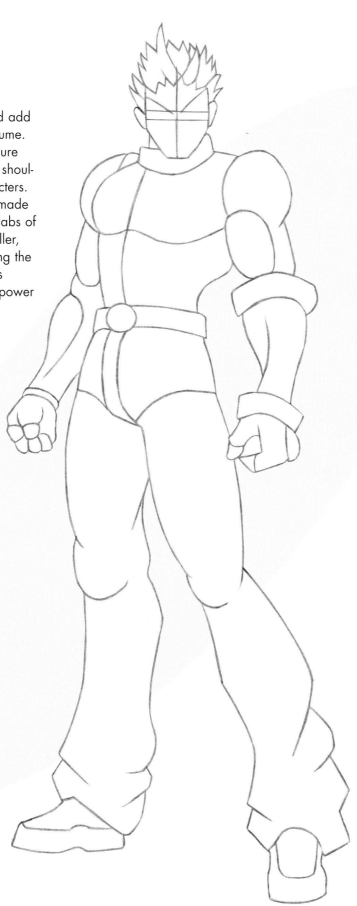

STEP 4 ▶

It's time to give your figure drawing some life. Start to add in the smaller details. Notice how the ripples and creases on clothes can help to define the idea of muscles underneath (without actually having to draw them).

◀ STEP 5

Remember to keep the lines and the detailing simple, but notice that tiny details, such as giving your character stubble or a slight frown by angling the eyebrows downwards, can add a great deal to your picture.

Learn to draw realistically—once you've gained some proficiency in this, try doing it manga-style. It's much easier to stylize something once you know the basics of anatomy.

QUICK TIP!

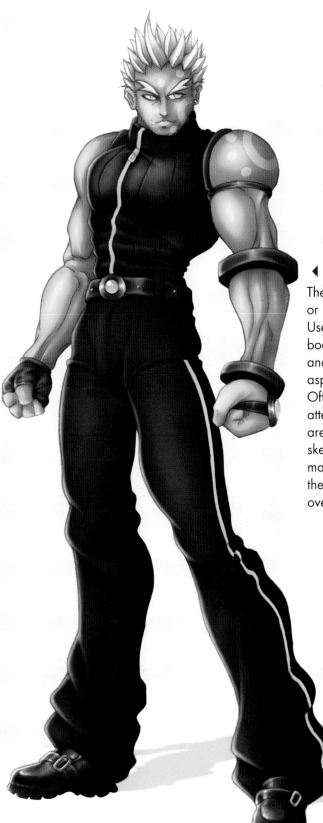

◀ STEP 6

The coloring stage can often make or break your figure drawing. Use careful shading to accentuate body parts, such as the biceps, and to highlight individual aspects, such as the hair or eyes. Often color can be used to draw attention to character aspects that are hard to highlight with just a sketch. You could, for example, match hair color with aspects of the clothes to build up a stronger overall image.

FIGURES

FEMALE 3/4 VIEW

STEP 1 ▶

This time, try using a different method to structure your figure. Instead of ovals and other shapes, let's construct the figure using simple, curved lines with dots to highlight the joints. It looks a bit like a join-the-dots picture!

◀ STEP 2

This technique essentially stems from the stick-people doodles that we've all done at some point or another. The emphasis is on keeping things simple, but think carefully about where the joints are as they accurately help construct a pose for your figure.

STEP 3 ▸

Now build up some bones around the original lines and dots. Before long, you'll end up with a figure that starts to resemble a human skeleton.

◂ STEP 4

You'll notice that the pose still looks slightly awkward at this stage, and the figure is robotic-looking rather than human.

FIGURES

FEMALE 3/4 VIEW

STEP 5 ▶

Look out for the neck at this angle; it connects up into the skull and should be obscured by part of the face. The midsection should be somewhat hourglass-shaped, but again, don't overexaggerate the curve unless you really know your anatomy (you have to know the basics before you can start bending the rules). Don't overdefine the lines on the behind, since there's little reason to. Be careful when drawing the arms; from the back, the elbows should be more prominent than usual.

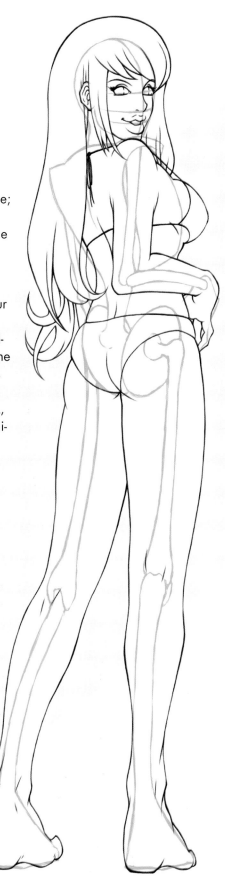

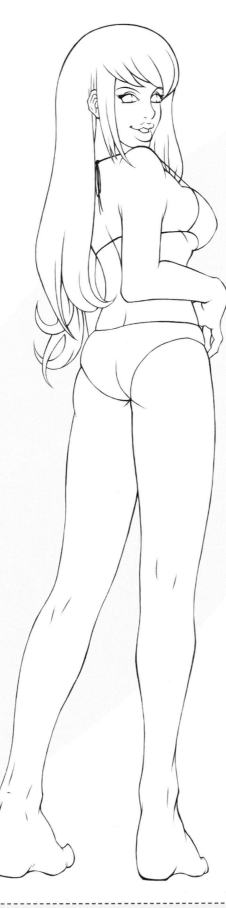

◄ STEP 6

Now that you've got some flesh on the bones, erase your original guide lines and start building in more details. Notice how very small, simple, curved lines help to give a suggestion of how your figure is posed, such as the curved lines at the backs of the knees and the slight arch in the back.

Experiment with as many varieties of media as possible. Chances are you'll find something you like beyond your pencil.

QUICK TIP!

FIGURES

FEMALE 3/4 VIEW

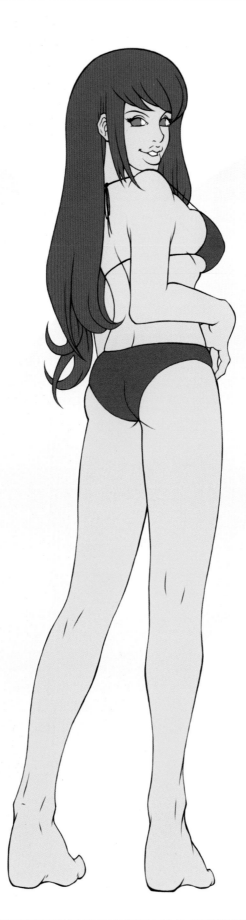

◄ STEP 7

Add some very basic blocks of color. Feel free to stop at this stage if you want to—your figure is now perfectly formed. However, if you really want to go to town…

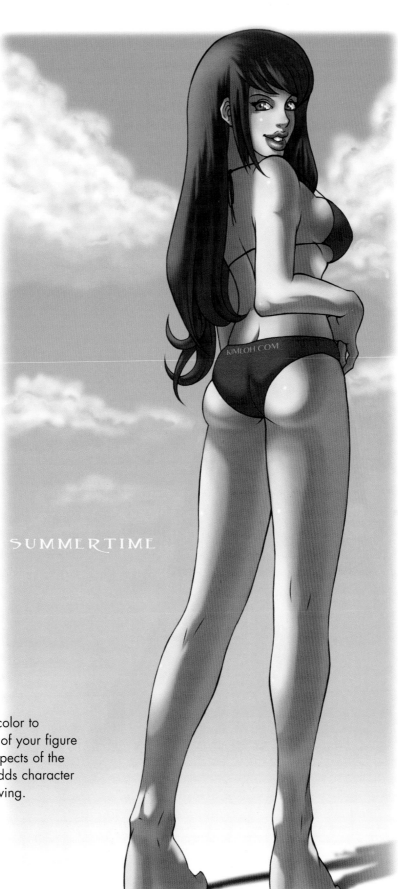

SUMMERTIME

STEP 8 ▶

...then you can use color to emphasize the pose of your figure and even suggest aspects of the backdrop. This all adds character and life to your drawing.

STEP 1 ▶

Remember all those stick people you used to draw in school? Here is where you realize how useful they were. Begin with a loose stick figure as your foundation. Note that the form is about 7 heads high. You can draw a line straight up and down from the top of the head to the bottom of the feet. Body mass is distributed equally on both sides for balance.

◀ STEP 2

The female torso can have a casual yet sexy stance by slanting the shoulders and hips in different directions.

◀ STEP 3

In manga, the legs are made to look slightly longer than the upper half of the body. The knees are located halfway between the top of the hip and the bottom of the foot.

STEP 4 ▶

Now we start to flesh out the illustration. You have to be good at drawing cylinders and ovals to do this correctly. Study muscle groups to get an idea of how the shoulders, arms, and legs are shaped. Try to use only curved lines. Nothing on a human being is ruler-straight, especially a female figure who is all curves!

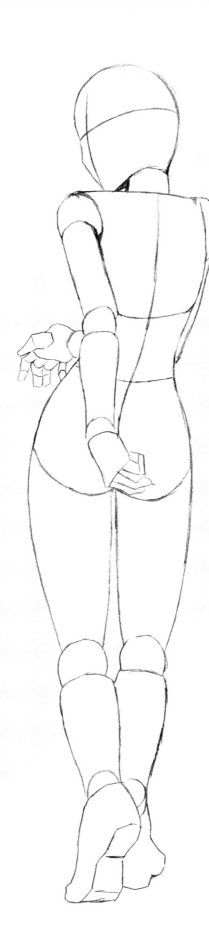

◀ **STEP 5**

Now start tightening up your art. Grab a kneaded eraser and start blotting away the fine, sketchy lines, keeping only the lines that you wish to use for your final piece. Tidying up your drawing at this stage makes the next stage much easier.

STEP 6 ▶

Gradually start to complete the character by outlining the fleshed-out sketch from the last stage and smoothening over all the joints used to build the illustration. The eraser is very important at this point as you remove stray lines to get a clean, usable piece of art.

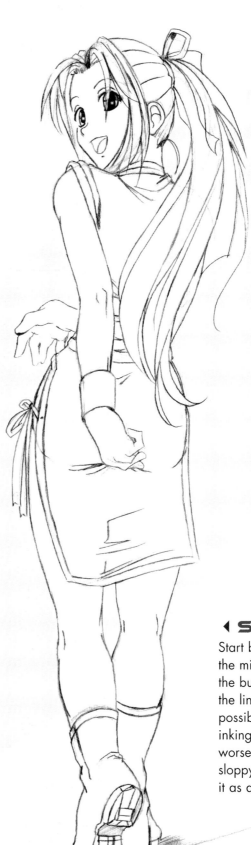

◀ STEP 7

Start by correcting any of the mistakes made during the building process and get the line art as complete as possible, in preparation for inking. There's nothing worse than inking over sloppy pencil lines, so make it as accurate as possible.

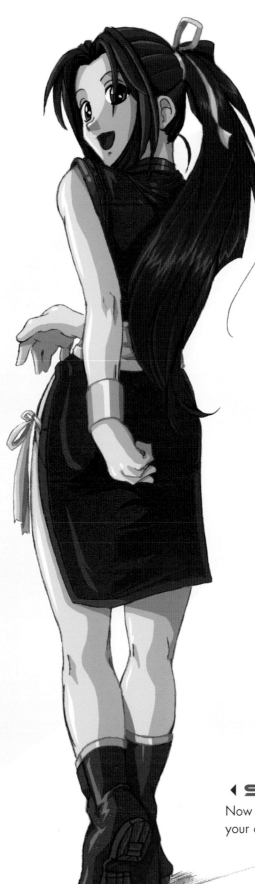

◀ **STEP 8**

Now use color to bring
your character to life.

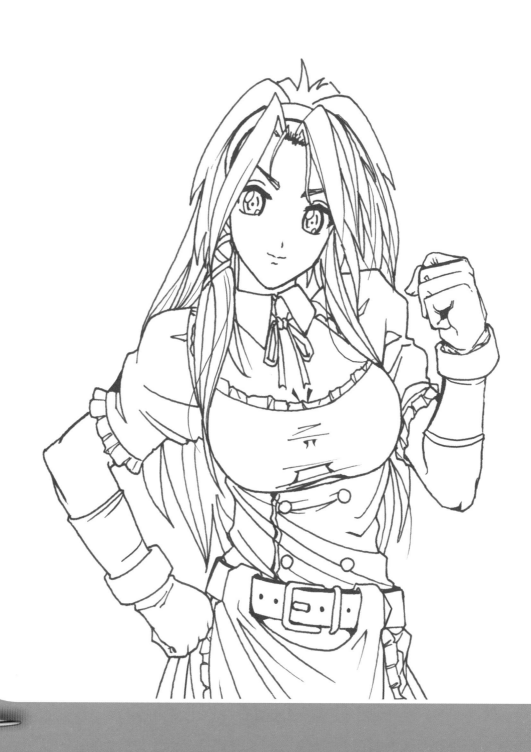

THING

Creating a character is not just about drawing the figure; careful consideration must be given to clothing and accessories, too. The clothes worn by a character not only enhance their personality and give us clues about who they are, but they open up a whole new range of drawing techniques. Whereas a body has standard forms and shapes, simplified to cylinders and circles, textiles come in many shapes, sizes, colors, and textures.

We see clothing as a three-dimensional form and surface on which light reflects. This shows up as folds and we can imagine what sort of texture a fabric might have by the shadows and highlights. Different fabrics reflect different amounts of light; leather, for example, is very reflective compared to tweed which absorbs light.

Have this in the back of your mind as you attempt to draw clothing that looks realistic. In manga, however, many costumes seem to defy gravity, such as billowing capes and tall hats that couldn't possibly exist in real life. This is where we can use some artistic license in making the character look dramatic and giving the picture added visual impact. Try sketching several outfits over the frame of a character and play around with the designs each time to see how far you can go without making it look ridiculous.

It is important not to feel daunted. In manga, you can simplify all these things and still achieve wonderful illustrations. On the following pages, a few secrets will be revealed that will help you come up with stunning results!

CLOTHING

I've included some examples of basic folds. Notice the movement in each instance. The fabric flows downwards if pulled down by gravity, but folds become more horizontal than vertical the further they are stretched. Also notice how the folds are sometimes nested within one another. Folds follow the direction in which the cloth is being pulled.

Generally, you shade along a fold line, or anywhere you think a shadow might be cast.

It helps to look at actual folds and see where you need to shade.

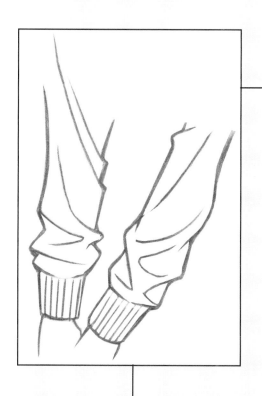

As practice, try sketching the drapes of a towel when slung over a chair. You will start to get a better feel for how clothing needs to be shaded.

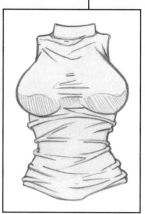

Remember to use shading to give your subjects more form.

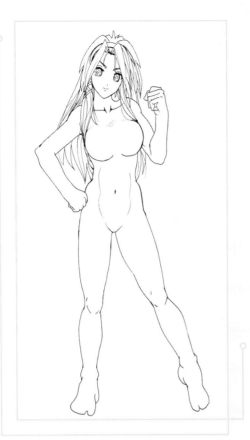

There are thousands of different styles for clothes, so rather than try to cover them all, I thought I would show you how clothes behave on the body. You can at least then get the physics right and design whatever style of clothing you wish.

When you first draw your character, don't worry about initially putting clothes on. Instead, make sure you have fleshed them out correctly. Clothes flow over the body like water. The folds on clothes are determined by kinetic force and gravity.

You have to imagine the way that the fabric will be pulled, both by gravity and the motion of the wearer. Notice the clothing is smooth and taut over areas that are bent or which push against the fabric. Fold lines radiate out and away from bends.

Imagine hoops around your arms, waist, neck, and legs. If you raise your arm, how does the hoop hang? Which part of your arm is touching the hoop? The part that touches it is where the clothing would outline your arm and the folds would radiate out and away from this point. Clothes bunch up and hang in the opposite direction to the motion of the body.

The most important thing to consider whenever you are drawing clothing or any type of fabric for that matter is the direction that the fabric is going to be pulled in. Folds are caused wherever the fabric is being stretched or pulled; figure out how exactly you want the fabric to move, and the rest is pretty easy. Remember to consider the figure beneath the clothing; the clothing should reveal the shape of the figure.

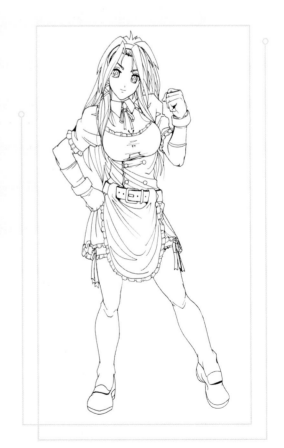

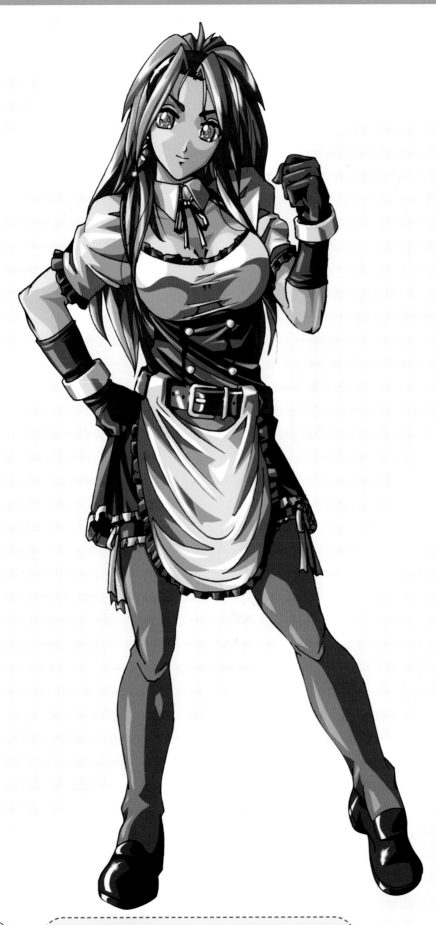

Having trouble with clothes? You can buy realistic paper dolls featuring styles from every decade to traditional clothes from other cultures!

QUICK TiP!

ACCESS
& WEAP

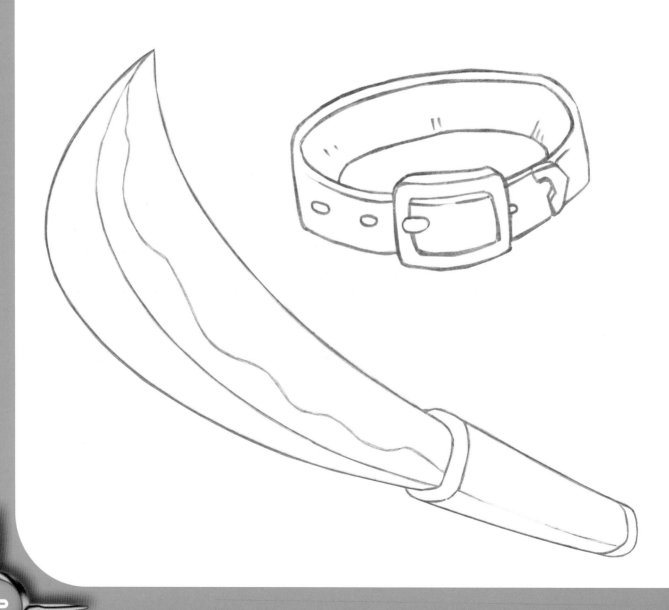

SORIES
ONS

In addition to clothing, think about adding extra adornments to your character such as trinkets, personal artefacts, and jewellery. Not only are these visually interesting, they also help promote the personality of your character, suggest events that occurred throughout their lifetime, and give clues about their culture and background. Consider what adventures they may have had and what souvenirs they might have picked up on their travels—a necklace, a bracelet, a ring, or a hat are all favorites, but your ideas will depend on the character's age, gender, and the setting of the story (science fiction, medieval, school, etc).

Another great way of emphasizing a character's occupation or interests is to highlight 'tools of the trade'. For example, a computer hacker may be inseparable from her laptop, a spy may have an array of communication devices all over his body, and most fantasy characters will have exotic weapons of some description.

In most modern and sci-fi comic book settings, guns and blades are often the weapons of choice, both because there is style to them and because they have great destructive power. However, manga is firmly rooted in Japanese culture and tradition, and it's important to remember that through martial arts, many everyday objects and farming tools were adopted as weapons. The most common of traditional weapons are the Katana (sword), Bo (wooden staff), and Nunchaku (two wooden lengths attached by a length of chain).

For more ideas, put some research into this topic using magazines, books, and the Web so you can adapt various weapons to your creations. Not only will this be rewarding, but you'll also be creating original designs that will be appreciated by those who view your work.

ACCESSORIES & WEAPONS

The most important point to remember when creating accessories, whether clothes, weapons, or jewellery, is to draw them with the necessary amount of detail. Be imaginative by all means but make the effort to fill in the details.

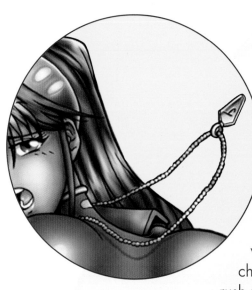

It is possible to draw the necklace by placing 6 circles next to one another, but does it look effective? Why go to all the effort of creating a visually stunning character but then rush the accessories?

You would think the buckle of a belt is simple to draw but most people represent it as a square box on a thick line. A little attention to detail will make your illustration look sharper. Draw the buckle as shown here with the strap overlapping the back end of the buckle and the thickness of the belt clearly visible.

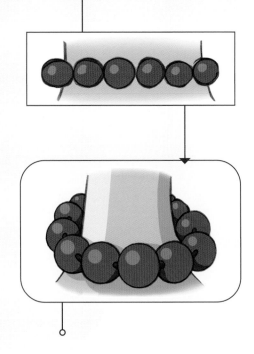

Because of the nature of manga, weapons are often very important accessories for many characters, and you may want to include some with your own creations. Look at these two examples of a knife. With the use of foreshortening on the larger of the two examples, you can create a very dynamic 'in-your-face' drawing—this adds a great deal of vibrancy and menace to your composition.

You might also want to consider the careful use of lens flares and shading to bring some realism and life to your accessories. Light glinting off a curved sword or a twirling mace can radically increase the dynamic impact of your illustration.

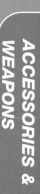

ACT

Nothing helps with action drawing like good reference material. Get your friends to pose for you or clip pictures from magazines. Any time you see a pose that you like, GRAB IT! You never know when you might need it. After a while, you'll be able to draw from your imagination.

When choosing a pose for your character, think about his or her personality and how he or she moves. For instance, when walking, one character may strut along confidently while another may drag his or her feet and walk along with his or her head hung low. The mood you show depends on the pose, as well as the facial expression. Try to imagine how you stand or move in different moods.

The only way to get good at drawing action shots is to practice. In the following examples, I've covered running, jumping, fighting, and falling. Think about all the things you have learnt so far about figure drawing and clothing and bring them to bear on the examples that follow.

ACTION

FALLING

The key here is the stick figure and the line of motion. Lots of artists get all caught up in the clothes and muscles and details way too early in the drawing. The key to a good action pose is a strong foundation and the stick figure will help us with that.

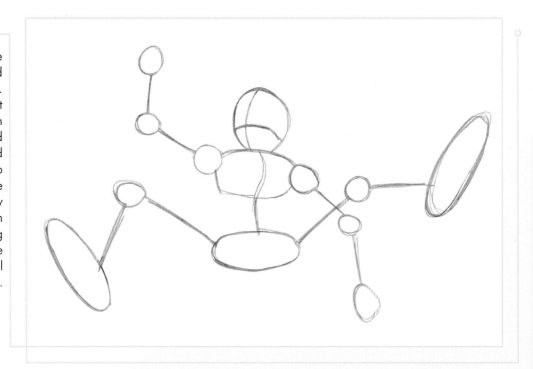

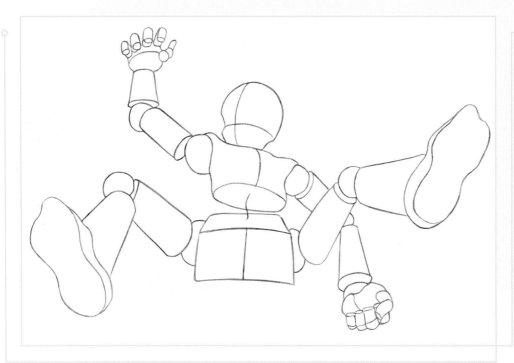

First draw the line of motion. This smooth, curving line runs from the top of the character's head, through the body via the spine, and out. Build the stick figure on this line and flesh out the character around it.

Draw! Draw! Draw! Bored? Take out a piece of paper and doodle. Tired of watching TV? Draw that favorite anime character! When you draw every day, it makes a big difference!

QUICK TIP!

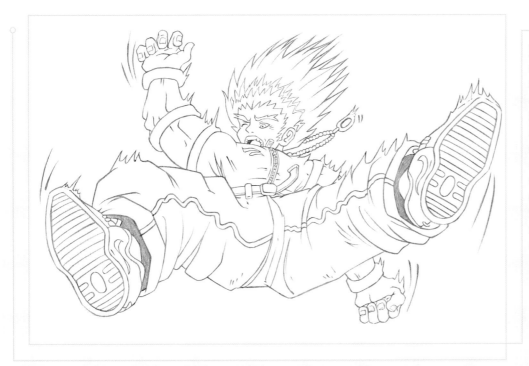

Here I've got a scary falling sequence going on. The character is waving his limbs and clearly dropping like a stone. Concentrate on the shape and angles of the limbs to make the action more believable and dynamic.

Use other features, such as the hair, clothing, and accessories, to emphasize the speed of the fall. Everything pointing upwards suggests the wind is rushing past as the force of gravity acts on the character.

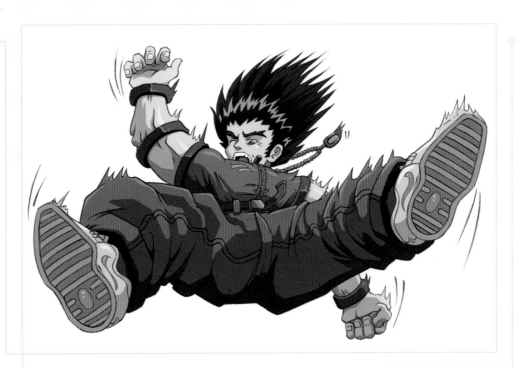

ACTION

JUMPING

STEP 1 ▶

The first key to drawing action poses is to go for broke. It's better to push the character too far than not enough. Go for poses that are dramatic, almost frightening! Action poses must also have a sweep to them, with the character traveling in a given direction.

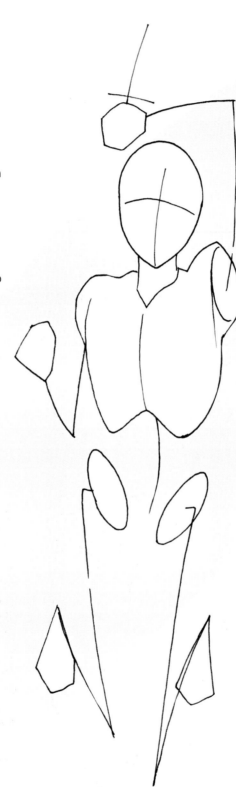

◀ STEP 2

This is as complicated as you should get when making a stick figure...stay fast and loose. Make little circles to show the position of the joints and the head. Don't worry about fingers and toes. Just make a solid stick person. Don't forget your line of action.

◀ STEP 3

The pose here is a prelude to another action. Clearly our character is going to descend on a target, using her aggression to either defend herself or attack someone else! You can clearly see the flow of the pose—it's a classic stance with the arm raised above the head, adding huge drama to the illustration. The knees are tucked up, clearly showing that the character has left the ground! The rest of the legs and torso are fairly straight. The raised arm also suggests a forward and downward motion.

ACTION

JUMPING

STEP 4 ▶

You want to make it seem as if the character is bursting out of the picture, almost attacking the reader! You achieve this by making it appear as if the figure is above the viewer, coming down ambush-style! Notice how the character's clothing suggests a lot of movement. Even the frown of the eyebrows shows the character is making an aggressive downwards movement.

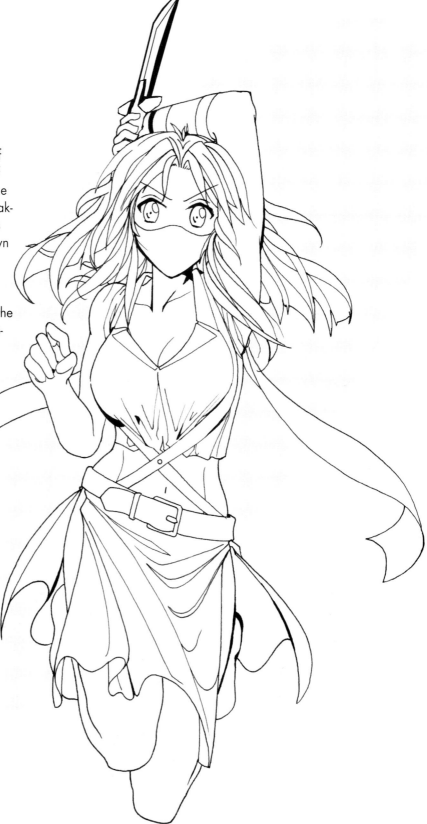

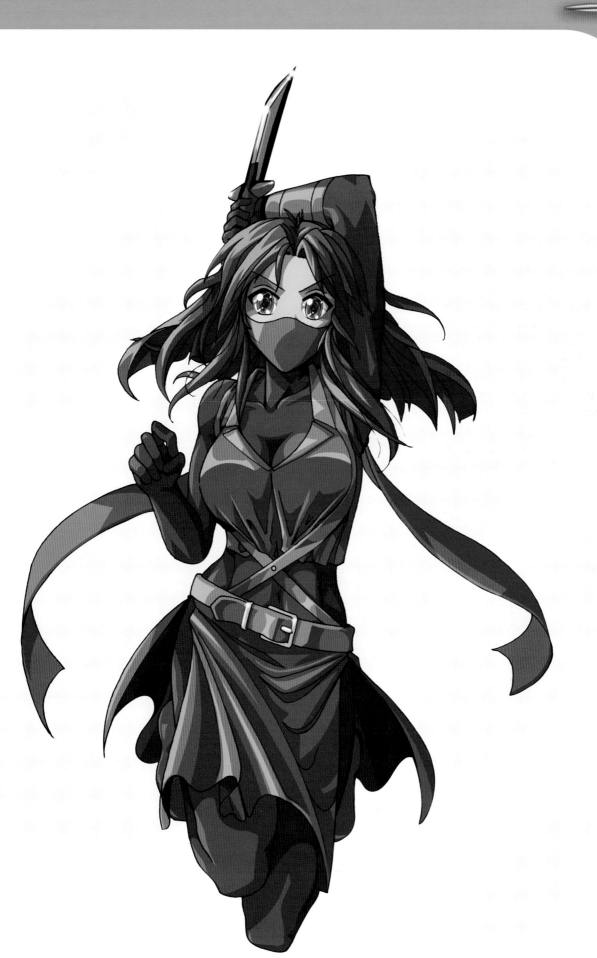

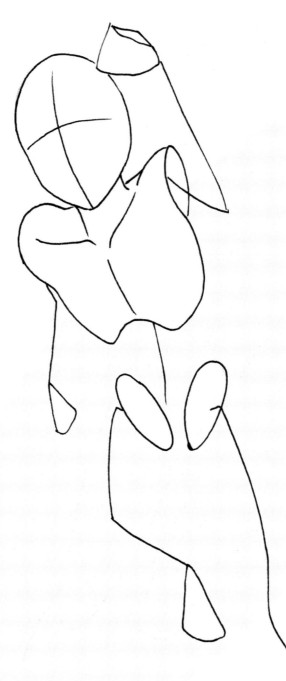

◀ STEP 1

Use your knowledge of creating figures to sketch out your runner. Notice how a curved or angled line of action can be used to pull your character towards the viewer. It can also be used to help exaggerate a position.

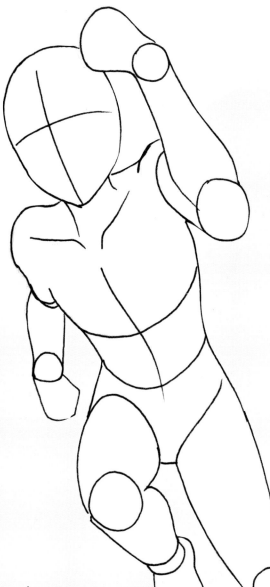

STEP 2 ▶

Here you see the use of some foreshortening in the pelvis and the shoulders because we are looking at the character from a slight angle. When running, the center of gravity lies in front of the resting point.

Before you ink, try and relax your hands in some way—a shaky hand will leave the line art looking messy.

QUICK TIP!

95

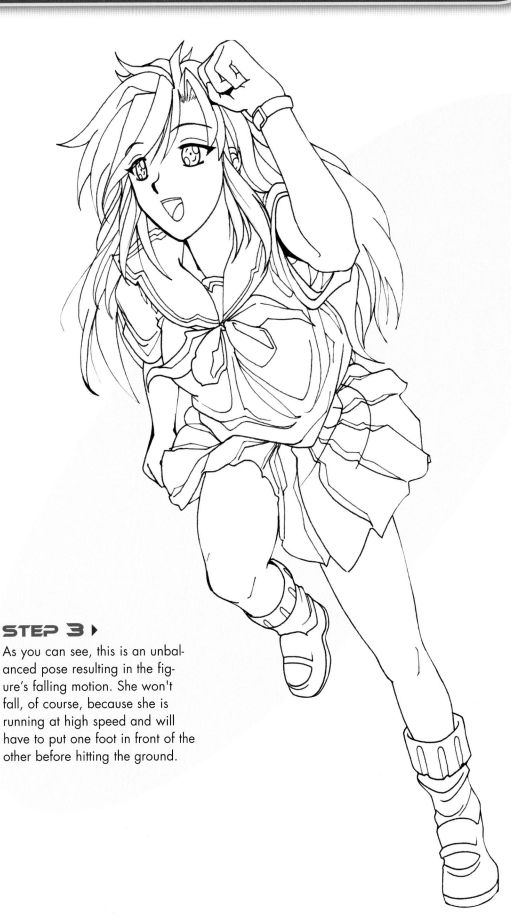

STEP 3 ▶

As you can see, this is an unbalanced pose resulting in the figure's falling motion. She won't fall, of course, because she is running at high speed and will have to put one foot in front of the other before hitting the ground.

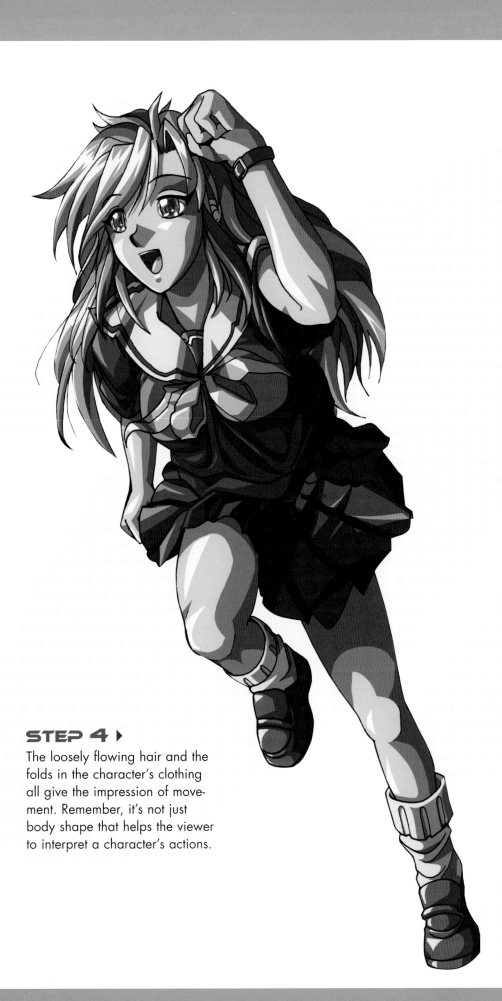

STEP 4 ▶

The loosely flowing hair and the folds in the character's clothing all give the impression of movement. Remember, it's not just body shape that helps the viewer to interpret a character's actions.

With a fighting illustration you've got to make the picture as dynamic as possible if it is to have any effect on the viewer. Rough out your illustration using the tried and tested ovals and sticks. It doesn't look like much to begin with but already you can see the movement in the composition.

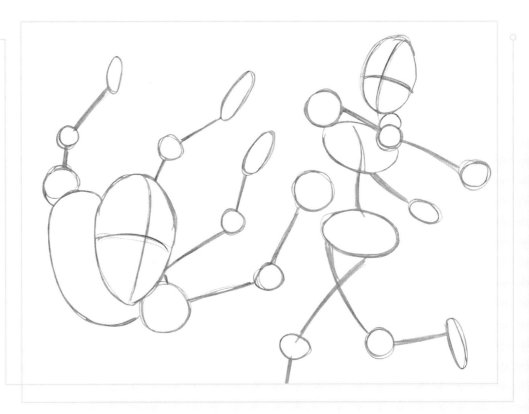

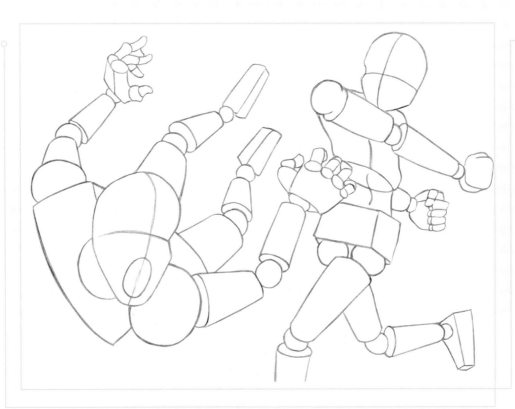

As you start to flesh in the two figures, you can begin to see the dynamics of the punch. The force of the punch is shown in the shape and position of the characters. Choosing an angle that shows the moment of impact really pulls this action piece together.

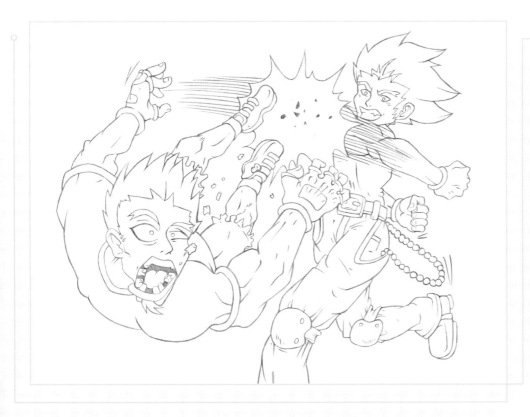

Now THAT had to hurt! The use of foreshortening crumples the target's body. He probably won't be getting up for a while. Also, the attacker's body is very much a part of this punch—all the balance is thrown into it, giving the impression of a mighty delivery.

When you get to the stage of cleaning up your work and adding in details, be sure to incorporate lines that translate the action taking place. The edges of the fist and arm are quick strokes following the direction that the arm is traveling in. The head is knocked back from the point of impact.

Booooom!

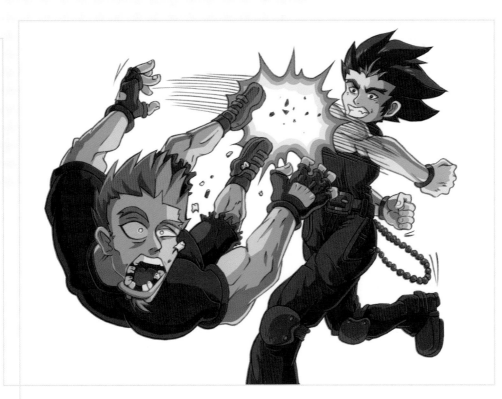

COLO

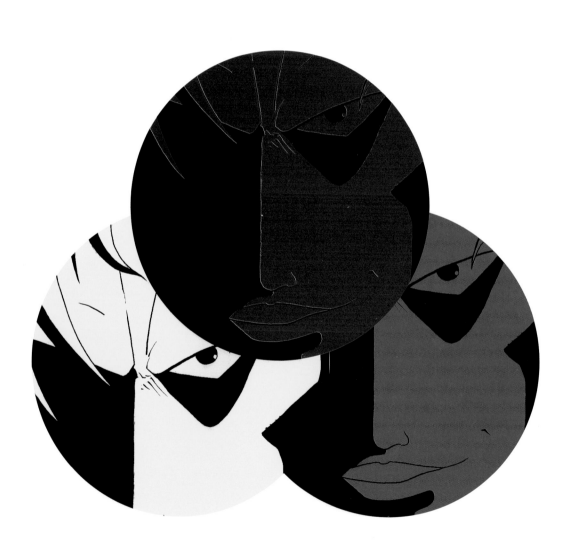

ꓷRING

All great compositions partly owe their success to color. Maybe you think the artist just needs to 'stay within the lines' and then they end up with a fantastic picture. Well, it's not as easy as that. Over the following pages, you will find a selection of tips for getting the most from color, and valuable advice that will help you think before putting a single pixel of color in your drawing.

Okay, I know what you're thinking: 'Come on! I know what red, blue, or yellow looks like. I don't need you to tell me about it.' Maybe so. But remember, when you're out of ideas, always come back to the basics. You might learn something new!

Always remember that colors will create a certain atmosphere in your drawing. So think carefully about what mood you want to give your work before starting out with a color simply because it's your favorite. It doesn't work that way.

COLORING

COLORS

COLOR

Some useful terms you should familiarize yourself with:

HUE

A pure color; the color itself (red, yellow, blue, etc).

INTENSITY

This refers to the brightness of a color. In order to lower a color's intensity (dull down), add a small amount of its complement, its opposite color (more about complements later). For example, to dull down red, add a bit of green. If equal amounts of red and green are mixed, the color becomes brown, not a dulled-down red.

VALUE

This refers to the lightness or darkness of a color. For example, to lighten a color, simply add white.

PRIMARY COLORS

Red, yellow, and blue. They are the basic colors that make up all the other colors of the color wheel. For example, if you mix red and yellow, you get the secondary color (orange). Mix red and blue—you get purple. Mix blue and yellow—you get green. And, from there, you can create tertiary colors like turquoise (a blue-green color) or fuschia (a red-purple color).

SECONDARY COLORS

Orange, violet, and green. These are made mixing any of the primary colors as explained above.

TERTIARY COLORS

Colors made by mixing a primary and its secondary color.

NEUTRAL COLORS

When equal amounts of two complementary colors are used, a neutral gray or brown is made.

COLOR MOODS

These are the basic moods:

Warm colors (*red, orange*)—suggest heat, energy, passion etc.
Cool colors (*blue, green*)—suggest cold, calm, relaxation etc.
Light colors (*added white*)—lightness, freedom, air, floating etc.
Dark colors (*added black*)—oppression, small, closed area etc.
Colorful (*bright colors*)—excitement, life, strong energy etc.

Before we get into the real coloring tips, it's worth bearing a question in mind. Have you ever experienced looking at your drawing and saying 'I can't stop looking at this or that but I don't know why!' The answer probably lies in the color. Look at the following list. It shows which colors are likely to make the most impact, from the one that gets most attention in a picture to the one that gets the least.

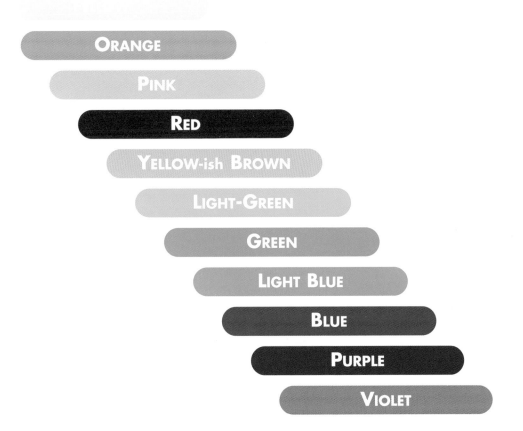

So before you go crazy with colors, bear this in mind—the little yellow hat you give your character could gain far more attention than you wanted.
Be careful!

SHADOW AND SHADING

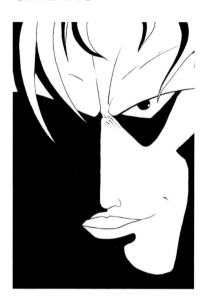

Shading can be a bit tricky at first but it's not as difficult as it seems. One side of a shape is light and the others are darkened. This is all you need to know when shading: what the light doesn't hit is darkened. Picture the light source and the object which is being hit by the light—which part will the light hit? How far will the light go? What you have to keep in mind is where the light source is coming from. If the light is far above, the shadow will be shorter: if the light is lower, the shadow will become longer. It's also worth remembering the shape of the object on which you are applying a shadow. Every shape has its own unique cast. The triangle has a pointy shadow, the circle has a circular shadow, the cylinder has a rectangular shadow, and the square has an 'L'-like shadow.

INKING

Inking is by far the most important skill that a manga artist needs to master. Although it is very similar to a pencil, a pen requires much more precision and patience. However, the rules that apply to penciling also apply to inking, so let us look at the basic skills of drawing lines before anything else.

The most crucial skill of drawing is to learn to control the thickness and consistency of a line. Drawing nice, clean lines sounds perfectly easy but this is a skill that takes lots of time to master.

The ability to produce clean lines originates from two factors—arm control and pressure.

A mistake that beginners often make while learning to draw is using only the wrist during the drawing process. In order to produce nice lines, you must use your entire arm. Using the whole arm increases control, thus producing straighter, more confident lines. Granted it is not easy (your arm will hurt for a while), but nevertheless, it's a skill that has to be mastered.

A good practice in using your arm for drawing is to draw vertical or horizontal lines across a moderately-sized sheet of paper. You will immediately notice that it is easier to draw clean, straight lines when you use your entire arm.

Thickness is determined by two factors: angle and pressure. The angle of the pen or pencil to the surface of the paper is proportional to the area on which the tip comes into contact with the paper. Therefore altering the angle of your pen can easily alter the thickness. In the case of a ballpoint or nib pen, an angle closest to 90° will produce the thinnest line. This is usually true for a pencil,

too, but since the tip becomes dulled fairly fast in a pencil, the point may not be at the center.

Pencils should be rotated to keep the same thickness and avoid oversharpening.

Pressure influences nib pens and pencils but has little or no effect on ball-points. Controlling the amount of strength exerted on the pen or pencil also takes a lot of practice. In general, a pen or pencil requires only a small amount of force to produce nice lines. Unnecessary pressure not only draws thick, unclean lines, but will ruin the tip. Try drawing quicker, lighter strokes to avoid exerting too much pressure.

A manga drawing is not truly complete until it has at least been inked. There are two major methods of inking that I am familiar with. The first is inking digitally with the help of a computer. The other method is by hand with actual pens. This is the more traditional inking method and still the most popular.

The best way to ink by hand is with an inking kit. These usually consist of a special pen with a slit at the end for the pen nib. Nibs come in many different styles and sizes, all designed to be dipped in a bottle of ink.

The results from an inking kit can be second to none, but if you can't face getting to grips with nibs and a bottle of ink, then never fear. There are some superb felt tips pens available that will produce excellent results. They come in a range of sizes, produce beautiful, clean lines, won't splatter, and you can get a decent set for under $20! However, be careful if you're left-handed as you may smudge the lines you draw.

No matter what type of pen you use, you will need to trace your sketch. You can either take the sketch itself and ink the sketch directly—then, using a soft eraser, rub the pencil lines away. Or you can get a 'light box' and trace the picture on to a new piece of paper. This second option might be preferable for the beginner as you don't run the risk of ruining your original sketch.

COLORING SHADOWS, SHADING & INKING

Rushing your inking might leave mistakes or unwanted and stray lines, so take your time.

QUICK TiP!

SCAN & CGING

NING

What is CGing? CG is short for Computer Graphics. Sometimes, you'll hear CG being referred to as CGI, which means the same thing, Computer Generated Imagery. CG and CGI are broad-ranging terms that cover any type of artwork made on a computer. From a scratchy image put together in Windows Paint, to a manipulated and edited photo in Adobe Photoshop, these are all examples of CG.

This section is not 'an-everything-you-need-to-know about CGing'—we'd need a whole book for that! But I will cover some aspects, from scanning and clean-up to coloring, to provide a very basic foundation in CG artwork.

Why CG? Have you ever heard anyone say, 'Everything's going to computers'? That's partially the case here, and there's a good reason why. Computers are capable of so much! Over the years, computers have evolved into tools for a vast range of different uses. At first, computer graphics were simplistic and fake-looking. Graphics software had to be written in-house and was hard to understand and utilize. Nowadays, however, computers and their users are capable of producing imagery that looks just as good as traditional style artwork and sometimes even better. Add that to the flexibility and functionality of computers and you've got a pretty good reason to make the jump to CG.

SCANNING

It's important to be able to transfer your pictures into a digital format on the computer without losing any of the original quality. It's also good to know how to enhance your images to make them look cleaner and sharper than your original artwork.

A scanning menu or window appears. Set the scanner to 300dpi (dots per inch) and 50% or 100% print size. I usually use 50%, as I only have 120MB of RAM on my PC. Unfortunately, Photoshop has a tendency to crash if you have really large files and not enough RAM. There are two reasons for scanning at 300dpi instead of 100 or 70.

Firstly, the scanned image will show up clearer because the scanner is picking up more individual dots from the artwork, and the more detail picked up, the more accurate the image is. Another reason is that if you intend to color the work, it's always best to start out with a large-sized picture so you can color fine details close up and at a decent image resolution. You can then adjust the size of the image if you intend to publish it on the Web etc.

If the scanned image is very small, it will be a lot harder to color and the final image quality will be poor.

Make sure that the scanner lid is firmly down. I

usually leave a heavy weight on it while it scans, so there's always an even pressure being applied to the scanned piece of work. If you were to hold the lid down manually and you were shaking, the scanned lines might come out looking crooked. The closer the image is to the scanner's glass, the more detail the scanner will be able to pick up.

Sometimes if the scanner lid isn't shut properly, outside light can get in and reflect on the image, which further reduces scan quality.

If scanning black and white line art, set the scanner to either Gamma 1.0 or Gamma 1.5. You'll get slightly better results

depending on the scanner and what type of work you are scanning. Make sure the scanner is scanning in GRAYSCALE and not B/W (black and white) or RGB/CYMK (color). The bad thing about B/W is that the scanned lines are black and white pixels only, and the lines are not anti-aliased. The downside of RGB is that the scanner will pick up unnecessary colors, when all you want is the black and white line art.

If your picture takes up more than the scanner's surface area, you will need to scan it in two halves and join it up later. Once again, while scanning, make sure the lid is pressed down where the second half overlaps or you'll end up with a big, faded gray area near the edge of the scan. Though this is important, don't press down REALLY hard so that it leaves a great big crease in the middle of the work. After scanning the first piece, scan the next with exactly the same settings as the first (300dpi, gray scale etc).

SUMMARY

- Set scanner to 300dpi at 50 or 100% print size
- Make sure the scanner lid is firmly down
- Scan at a Gamma level to suit your artwork, usually Gamma 1.0 for ink work and 1.5 for pencil
- Scan in grayscale

CLEANING-UP

Now after I've scanned my work into Photoshop, I'll need to clean it up.

The first task is to adjust the levels: Image –Adjust –Levels (CTR+L). Just spend a bit of time tweaking the gamma levels until the lines look nice and dark and the white background goes pure white without any discoloration or smudges being visible.

You might prefer the look of really dark lines if you've just scanned in some pencil work, or you might like to keep it lighter like the original. It's personal preference really. I usually go for something twice as dark as my original sketches because I usually draw with a 2H pencil. Alternatively, you might want to fiddle around with the brightness

and the contrast: Image– Adjust –Brightness. I've seen so many pictures that could have looked twice as good if only the artist had spent time cleaning up the image and making the lines look sharper, so it's very important to prepare the image in the correct way, whether you wish to color it or not.

Sometimes when you scan, the image won't appear dead straight, so you might want to adjust and rotate the canvas slightly. Usually I'd adjust the canvas size of my image making it slightly bigger around all the edges by 100 pixels or so. Then Image –Rotate canvas –Arbitrary, then rotate CW (clockwise) or ACW (Anti clockwise) from 0.4 degrees to 4 degrees, or however much you need to get the image lined up perfectly. Now you'll want to crop the image. Using the crop tool is ideal for getting rid of any surplus border. It's always a very good idea to crop a picture down to size if there's a lot of unnecessary blank space.

There might be a few smudges or random dark

unwanted pixels still on the image. To get rid of these, use the pencil or paint-brush tool and color white over those areas. To clear any mess out of small nooks and crannies, you might want to try using the Pixel selection tool, then simply fill in the selection you wish to clear with white, or just click Delete, but make sure white is also your secondary color if you do this.

Now your picture should be clean and looking good. If you don't want to color in the line work, and wish to now save your image, adjust the image size: –Image –Image size. You'll possibly want no more than a pixel width of 500 pixels, but it depends on whether your image has lots of detail in it or not. I suppose you'll have to be the judge of what image size looks best for your particular picture, but have a look at other artwork sites on the Web and see what sort of sizes they use for their pictures. You can do this by right clicking the full-sized image and selecting Properties.

To join up two separate images, adjust the canvas size (–Image –Canvas size) of scan #1 to little over double and make sure to have white selected as your secondary color. Now go back to scan #2, select the layer Background in the layers tab and drag this layer on top of scan #1. Use the drag tool to move scan #2 so it fits in perfectly (or nearly) next to scan #1. A good tip when adjusting the position of scan #2 is to zoom in at 100% and get the lines flush with scan #1. If the lines simply refuse to join up properly, you might need to rotate Scan #2: –Edit –Transform –Rotate. Use trial and error to very lightly rotate the layer and see if it joins up better after the rotation. After you've got it lined up, flatten the image and go though the previous preparation process.

SUMMARY

- Adjust the levels to achieve a sharper, cleaner look
- Rotate the canvas or image if the scan is not dead straight
- Crop the image
- Clean any extra smudges and pixels

with the pencil and pixel selection tools.

COLORING

If you want to digitally color your line work, there are many ways to do this. Here's a very simple method to get you started. To begin with, adjust the image mode to color: –Image –Mode –RGB. Then, in the layers tab, drag the background layer onto the 'new layer' icon, which will create a copy of the background onto a clean and adjustable new layer (otherwise you won't be able to move the out-lines on to the top in the layers tab).

Delete the bottom 'back-ground' layer and rename the 'copy-of-background' layer to 'outline'. Next, check the preserve trans-parency box for this layer.

While the outline layer is selected, go to the layer drop-down menu and select 'multiply'.

After that create a new layer and call it BG or Background. Now, on the background you'll be able to color underneath the lines of the outline layer, but on top of the white of the outline layer!

If you draw anything that includes nature, get some nature books. Or look at the nature around you. Many people draw trees in the same way or use the same colors—brown and green. Have a look—you will notice there's more to trees than brown and green!

QUICK TIP!

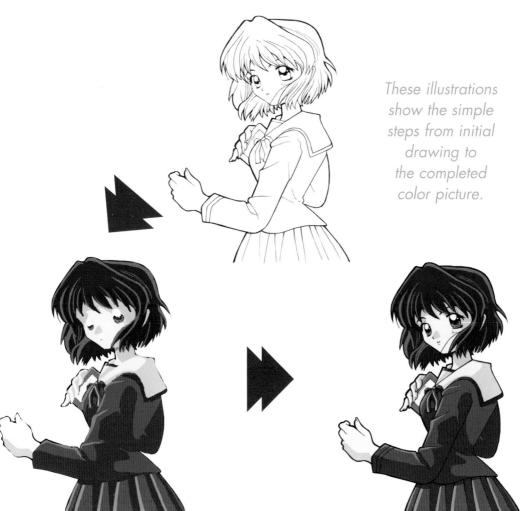

These illustrations show the simple steps from initial drawing to the completed color picture.

Alternatively, go to the channels tab and click the circular channel selection icon. The image should be filled with dotted lines. Next click delete—this will get rid of all white areas. Deselect the channel selection and then move back to the layers tab. Since the preserve transparency box is checked, you can then reapply black to the outlines by using the pencil tool with a brush size of 300+, then going over the whole picture to restore black to the outlines. Create a new layer underneath called BG or Background and you'll be able to color underneath the remaining outlines!

SUMMARY

- Change image mode to RGB
- Turn the background layer into an adjustable outline layer
- Multiply the layer, then color underneath

OR:

- Delete the white area of the outline layer by using the channel selection icon
- Then re-color the black lines with the pencil tool while preserve transparency is checked.

PHOTOSHOP—TOOLS/BASICS

The following tutorial covers the basics of learning Photoshop in relation to 'CGing' or comic book and anime-style coloring. There's more than just one style of coloring. Keep in mind what you want to achieve. If you're already familiar with Photoshop, then this might not be as helpful, but you might still pick up a few tips.

For this tutorial, I'm using Photoshop 6 on a PC, but most tools are the same as earlier versions of the program.

Ok, so you want to CG color your line artwork or line art and have just discovered that Photoshop is the thing to do it. The package is used in all sorts of illustration and graphic design fields, and most importantly, industry-standard comic books!

The tool bar is very similar to Microsoft's 'Paint', so I'm sure that you're already familiar with the layout and interface. First I'd recommend checking out the 'Tool Bar overview' in the PhotoShop help (F1). Some of the icons contained on the bar are very important, others not so important but most are used for a CG, so here's what they do:

MARQUEE TOOLS <M>

I use these a lot for what I call 'post production'. When the CG is all finished, I'll add extra shapes (details) to backgrounds and foregrounds. Tip: To create an outline from your selection, go to –Edit >Stroke (or right-click, stroke) and choose the line width. The color of the line will be the same as the primary color selection. Also I'll use it to select individual frames (on a sequential page).

MOVE TOOL <V>

Moves selections, layers, and painted areas. Useful but I don't use it too often during a CG.

LASSO TOOLS <L>

Like the marquee tool, but you have more control over the selections you make. This tool is used a lot for 'Cuts' and 'Cel style' solid tones. The Magnetic tool is rarely used. If you don't have a Graphics Tablet, you'll spend more time with the Polygon tool, since the Freehand tool can be tricky to use with a mouse. When I lay my initial flat base tone, this is one of the three possible tools I'll choose to use. After you've made your selection, fill it with color. I often make amendments to my selections, so if you've made a mistake, hold down SHIFT to add extra selections to your first selection—it's very handy. Use ALT to take away from your selection. You'll notice the – and + signs as you hold down the keys.

MAGIC WAND TOOL <W>

Don't be fooled by the name! It won't do your CG for you!! Mostly used if you have some really clean, inked lines to work with for laying flats. Select an area in your drawing with the tool, then –Select –Modify –Expand. Expanding the selection will

avoid a filled flat from looking as though it's all scummy around the edges. At the resolution I work at, I'll usually expand an extra 4–6 pixels without my selection going over the lines. Very thin lines might not work with this method, plus you might need to SHIFT add with the other selection tools to reach areas that the wand cannot get to.

Crop tool <C>
Only used at the very end to trim your finished art, or if your scan needs clipping back.

Slice tool <K>
Never needed it!

Airbrush tool <J>
I use it A LOT. After I've laid down my flat tones, I use this to render those tones. The best bit of advice I can give for this tool is to set the tool options to a low pressure. Something between 5–10% avoids an excess flow of paint and possibly a muddy-looking rendered tone. Taking your time and using subtle shades will create a better result.

Paintbrush tool
It's used a lot for Cel style in conjunction with the polygon lasso tool. It's also another method for laying down flats. When I use this tool, I set the hardness to 100 and spacing to 1 for solid, clean brush strokes.

Pencil tool
(*With same icon as paintbrush.*) I've only really used a size 999 to quickly reapply a flat tone on a locked layer if I've made a mistake and want to start again.

Clone stamp tool <S>
Never needed it but I could see it coming in handy for SFX.

History brush tool <Y>
This brush and I don't have much history between us—never used it.

Eraser tool <E>
I use this one a fair bit. A good tip is to use it on a locked layer tone so that the secondary color selection is used. It saves time swapping and picking a second color because I have my tablet pen button set to eraser.

Gradient tools <G>
DON'T try to rely on these instead of an airbrush. The only thing I'd use them for is part of a background. Generally these are what slackers who think they're CGing use.

PAINT BUCKET TOOL <G>

(With same icon as gradient.) Used for filling selections in with flat tones, nothing else.

BLUR TOOL <R>

Occasionally used to help bend colors and to get rid of seams.

SHARPEN TOOL <R>

(With same icon as blur.) Hardly ever used.

SMUDGE TOOL <R>

(With same icon as blur.) Used a little more often than the blur tool and takes a lot of memory to use. Sometimes you'll need a really high spec PC to use a large smudge brush, and even then it'll take 5 minutes to apply the change!

DODGE TOOL <O>

I've seen people achieve excellent, more realistic-looking results with this tool, but it's difficult to handle and achieve a more subtle graded tone. I'd recommend using it on 50% pressure or less and apply it to Midtones.

BURN TOOL <O>

(With same icon as dodge.) The opposite to Dodge, but used less. I'd rather start with a dark tone, then get lighter with dodge, than start with a middle tone and use both dodge and burn.

SPONGE TOOL <O>

(With same icon as dodge.) Alters the amount of 'pigment' on a rendered tone. I've never really needed it.

PATH SELECTION TOOLS <A>

Never used it, since I don't use paths very often.

TYPE TOOL <T>

Adds text! Usually just for post-production or details on a character.

PEN TOOLS <P>

Similar to the polygon lasso (dot-to-dot style selection), but you have a lot more control over it. I never use it.

CUSTOM SHAPE TOOL <U>

Most important is the line too which draws straight lines. Not used much.

ANNOTATIONS TOOL <N>

I can't see how this would be at all useful unless you're just really bored!

EYEDROPPER TOOL <I>

I usually use it every time I CG. It's easiest if you select a brush. If you're painting with that brush and notice you need to grab some color from your canvas, hold ALT and the brush changes to the eyedropper.

HAND TOOL <H>

I use the scroller on my mouse to move up and down an image or just use the scroll bars on the right and bottom of the window.

ZOOM TOOL <Z>

I zoom in and out of my images a lot, but never do it via the tool icon. Just use CTRL and + or – instead, much easier!

So now you know what the tools do, you'll need to know what layers are. Layers work like sheets of acetate—you know, like they use in animation? The stuff you paint onto one layer won't affect another layer in the layer tab. If you paint on a layer above the one below, you'll cover up the bottom layer BUT not paint over it. Go to Photoshop Help (F1) and read the info about layers, while experimenting on your own. Layers are a very important part of the CGing process and you need to know how you use them and how they work.

Once you've laid your flat tone, it's ready for CGing, so lock it. By locking that layer, it effectively creates a mask so you can only paint on the flat and nothing else, which is the best thing about layers! By putting different colors on different layers, you can render each individually without adding unwanted color to the girl's face or tone on the guy's jacket. I could write a book on layers and CGing alone, but Photoshop's Help files have the same info and practice really will make perfect!

SUMMARY

I hope this gives you an idea of the tools that are involved in coloring your work in Photoshop. There are similar programs, such as PaintShop Pro, which is a great alternative if you can't get hold of Photoshop.

STORYB

ᗤARDING

There is nothing better than taking a character that you've created and putting them in their own comic strip. However, this can be a very time consuming process and also hard work! Here are a few useful things to remember:

The first and most important lesson when drawing a manga page is not to waste too much time on setup. Every page that you waste on boring setup brings the whole project closer to being a dull end product. Ideally, the setup at the beginning of the comic is either so brief it fits on a few pages or, even better, in a few panels. You could also throw it out as a text-only prologue or even just flash back to it later. Either way, do the bare minimum of setup and get to the meat of the story as quickly as possible.

You need to keep several things in mind while figuring out the page layout. For example, you should remember that a manga describes action. Thus, timing is important. Another aspect to keep in mind is the importance of the panel that you will be drawing. How much impact does the panel carry? In general, the bigger panels attract more attention than smaller ones. Therefore big panels should be reserved for important scenes that need emphasis while the small ones are used for panels that aid the fluency among the panels.

Over the next few pages, you'll find an example of a storyboard—I hope it helps.

Ideally, the setup for your panels should always be brief and to the point, each page telling its own important part of the overall story.

Have a look at the panels opposite—this is a classic setup for a Western comic page, with the reader reading across from left to right. Plan out your whole story before you begin so you know exactly what will appear in each panel—remember, the fun is in the drawing, not agonizing over whether you've got enough panels!

It's a mistake to draw a manga page without writing the script in advance and storyboarding it as well. But don't waste your time planning/writing scenes dozens of pages in the future. It just saps your energy from actually drawing the current pages, and, by the time you get there, your hard work will probably be obsolete anyway. Start sketching your panels out very roughly to see how they hang together on the page.

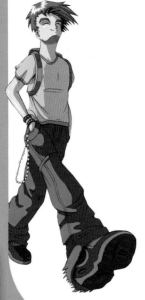

STORYBOARDING

It's important to keep the story moving at all times—a dead panel makes for a dull story! Basically, if you're not interested in drawing some event, just have a character allude to it and keep going.

With the panels here, I'm setting up a cliffhanger ending, forcing the reader to want to get to the end of the page. Who's the boy? Where is he? What's he doing? Why is that dangerous-looking character following him? Is that a knife? As a comic book artist, you are constantly building expectation and tension, drawing the reader into the plot.

Notice how the first panel gives you the big picture but without any of the detail. It is the smaller, more precise panels that unfold events.

STORYBOARDING

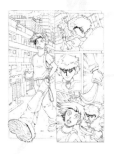

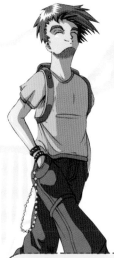

It's a good idea to draw as big as possible! It's easy to draw details on a huge sheet of paper, but adding tiny details on a small character can be very fiddly.

QUICK TIP!

Writers often use the phrase to 'murder your darlings'—this refers to beautifully written scenes or characters that writers are loathe to cut even though they don't add to the story as such. Cutting these elements is even more important in comics than in prose. Sure, it may sound great now, but when it comes to the time to draw it, and draw it, and draw it…you'll be tearing your hair out halfway through from boredom. And if it bores you, think of what it'll do to your readers.

Cut mercilessly to the 'good stuff' as soon as possible on the page. Similarly, if you find yourself writing basically the same dialogue twice—for example, a situation that has to be explained a couple of times to different characters—you're doing something wrong.

Look at how this is now coming together. As the artist (and storyboarder), you are implying a particular turn of events. Is your friendly, happy, harmless teenager about to be attacked for no reason by a knife wielding-maniac? What will happen? The reader has to turn the page to find out. It is very important to create this element of suspense with your images.

Alternatively the boy could have dropped his knife and the other guy is chasing after him to give it back. But this seems unlikely given the way the characters have been drawn. Your work on expressions and figures will come in extremely handy here!

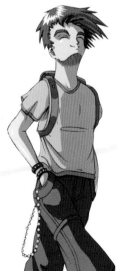

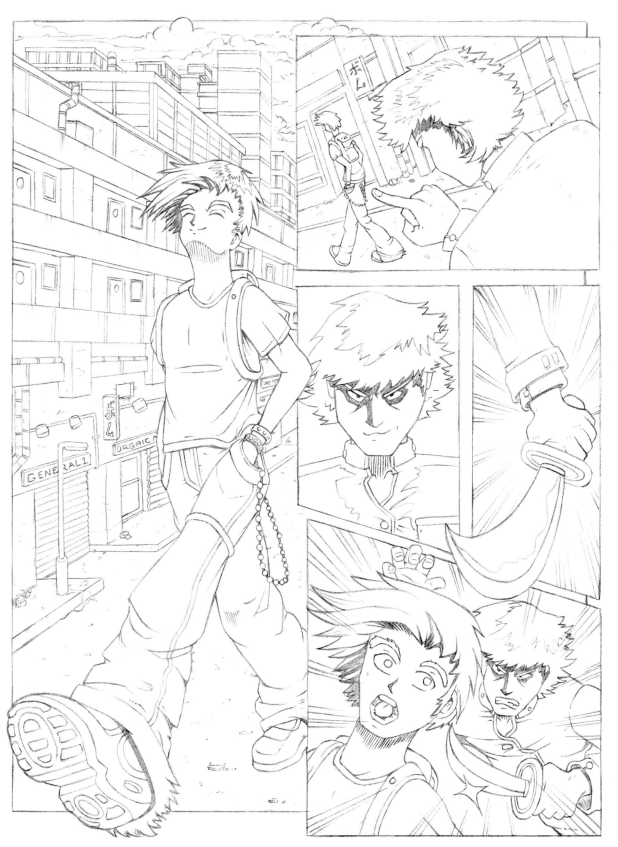

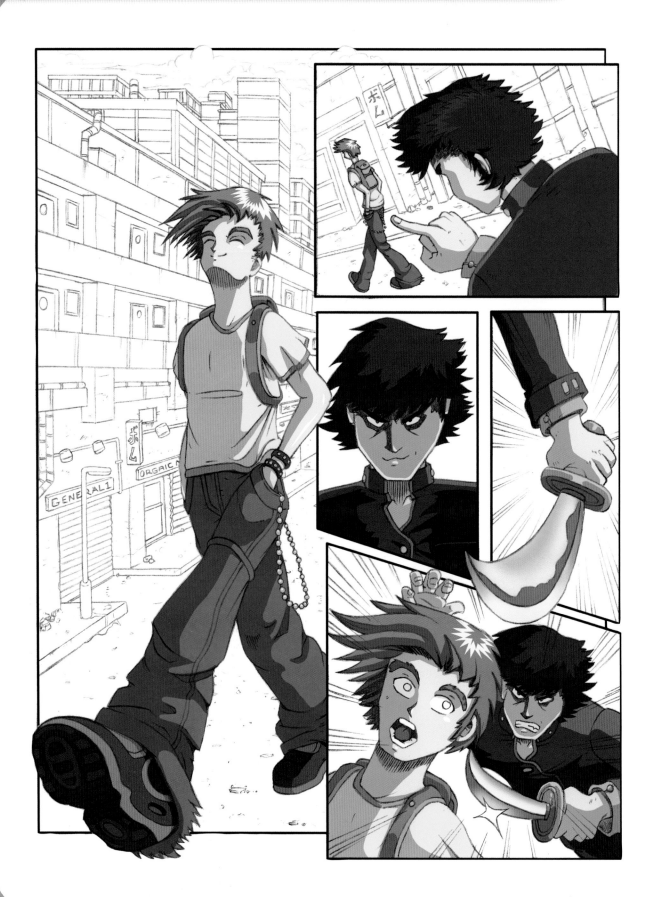

Notice how this whole plot has been created without using one single word of text, and yet the reader knows exactly what is going on. We can now use coloring to hit home a few points. The 'good guy' is wearing bright colors to match his cheerful disposition. He has no worries and no enemies.

The 'bad guy', on the other hand, is wearing black, has dark hair and shadows around his eyes. Look at those sharply raised eyebrows—scary! Notice as well how the technique of foreshortening is used to make the knife seem much larger and more frightening than it actually is.

I've also used action lines to suggest the speed and surprise of the 'attack', and a lens flare on the knife to give it a wicked glint.

STORYBOARDING

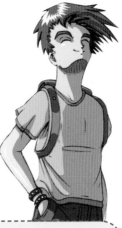

If you feel you have no new ideas for drawings, redraw your old sketches—you'll be pleasantly surprised by the improvement and hopefully it will give you the inspiration to get over your creative block!

QUICK TIP!

STORYBOARDING

Here is where you bring it all together. The gray, industrial coloring of the background ties in with the gritty, dangerous situation of the storyline. The teenage boy seems out of place roaming these shadowy, deserted streets. But the man in black seems perfectly at home in this dark environment. It becomes clear who is the outsider.

In just five panels, we have created an exciting, suspenseful plot, with interesting characters and a great cliffhanger. Everything in these pictures helps build the story, from the expressions to the coloring. Try your own storyboard—it's a fantastic way to get the most from your character creations.

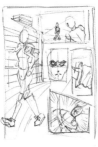
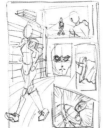
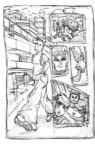

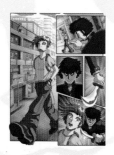
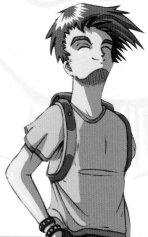

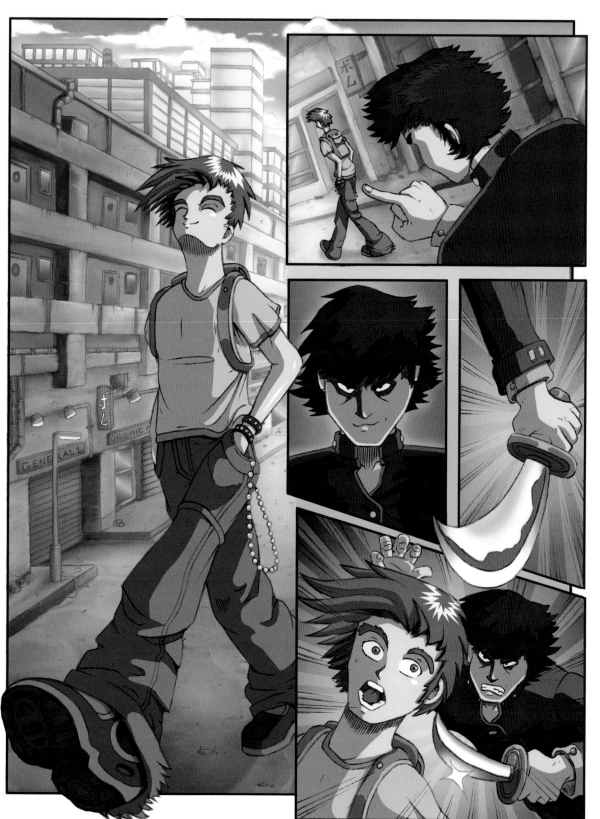

CREAT
CHARA

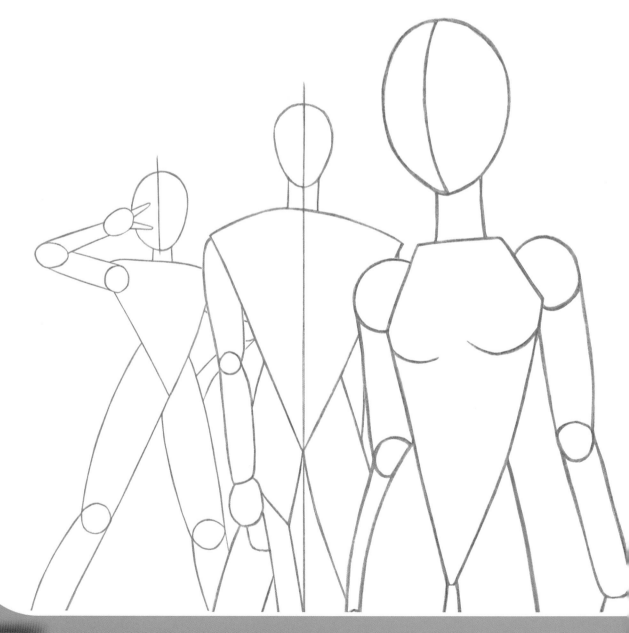

NG
ACTERS

Manga style is instantly recognizable and since the release of Katsuhiro Otomo's cult classic 'Akira' in the West in 1988, many comic artists have been inspired to pick up a pencil and give it a try themselves. Hopefully, you are now one of them, too!

In this book, you have seen how to construct characters and how to put them into settings and comic book panels. The character is undoubtedly the main focus of any manga or anime so practicing how to create and draw these effectively is the first step for any aspiring manga artist. Consequently, it has been the main focus of this book and hopefully you will have found the numerous tips, guides, and examples helpful.

Throughout the book, the emphasis has been on drawing from real life and referring to existing objects and people for your designs. Although stylized, all anime creations are taken from current or past objects and the designs which surround us. For example, a twenty-fourth century spaceship may be based on a nineteenth-century paddle steamer and a hero's spiky hair may have been inspired by a garden shrub. Look out for things like this in existing manga and keep an eye out for similar objects that you could reference to inspire your own creations.

Now it's time to gather up your materials, find a clear workspace, and start producing your own creations. I hope the characters on the following pages provide plenty of inspiration!

CHARACTER CREATION

A big part of developing a character is knowing what kind of body language they use. A big mistake beginners make when drawing pin-ups of their characters is to ignore the personality of the character they are doodling. I often see illustrations posted by artists that have a character standing with a weapon like they are sitting in a Sears studio for family photos...NO! Try and avoid using the normal stance. Think about your character...think about what it is your character does and what effect that would have on the way they carry themselves. Are they graceful? Are they clumsy? Do they laugh, skip, play, mope, drag, or cry? Picture this in your head before you put pencil to paper. You can say a lot with just a stick figure. Get your stick figure exactly right before you flesh in your character. A good foundation is important if you want your piece to have the right impact.

Check the following examples of creations to help you along your way.

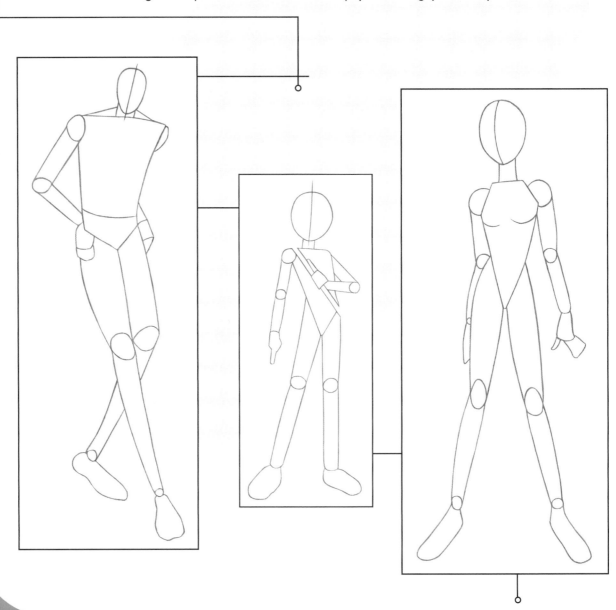

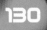

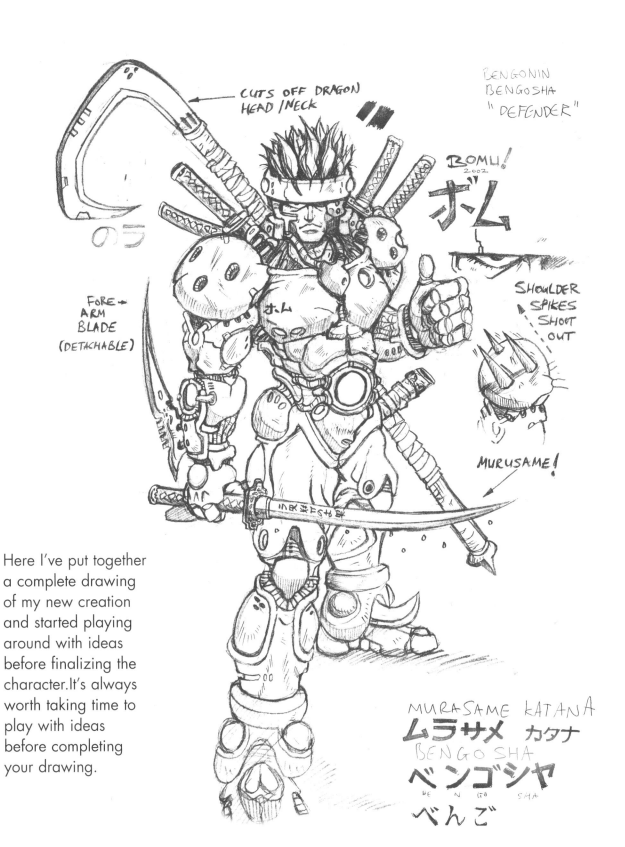

CUTS OFF DRAGON HEAD/NECK

BENGONIN BENGOSHA "DEFENDER"

ROMU! 2002

ボム

のラ

FORE-ARM BLADE (DETACHABLE)

SHOULDER SPIKES SHOOT OUT

MURUSAME!

MURASAME KATANA

ムラサメ カタナ

BENGO SHA

ベンゴシヤ

BE N GO SHA

べんご

Here I've put together a complete drawing of my new creation and started playing around with ideas before finalizing the character. It's always worth taking time to play with ideas before completing your drawing.

Sometimes it can be a good idea to plan out more complicated scenes or poses before you draw them properly. I sometimes draw 4 or 5 thumbnail sketches to plan out just one picture. It can save a lot of time in the long run by getting rid of your mistakes at an earlier stage.

QUICK TIP

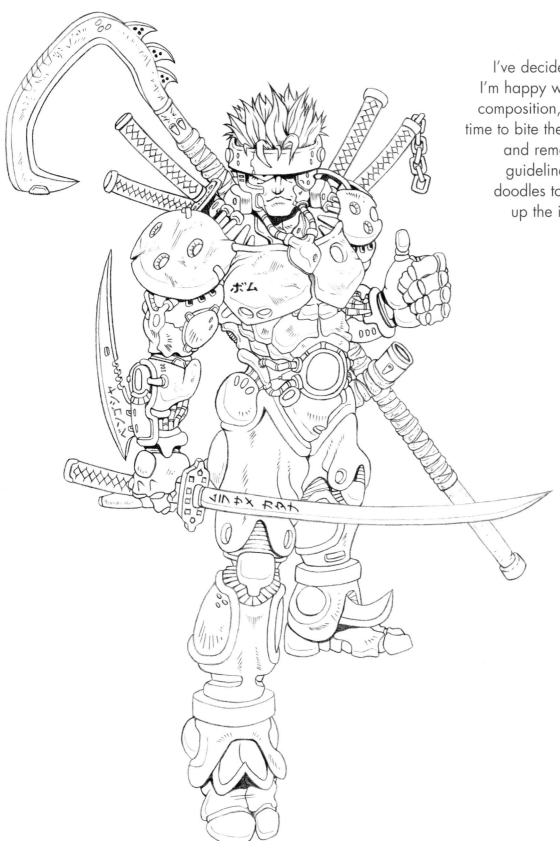

I've decided that I'm happy with the composition, so it's time to bite the bullet and remove all guidelines and doodles to clean up the image.

Inked in and fully colored this is him in all his glory!

Pretty cool.

There are a number of influences on the look of this character, and he's very much a combination of samurai warrior and mecha…

BENGOSHA

He's Bengosha— a Japanese cyborg warrior from the future where monsters, demons, and dragons have become a real problem in Tokyo after a parallel dimension portal opened up in Shinjuku 100 years ago! His father was a world-famous samurai master of Yosake Dojo and the secret owner of the legendary Murasame sword. After his father died in battle while he was still a boy, Bengosha inherited the Murasame and now acts as an élite defender of Tokyo.

NAME: **BENGOSHA**
WEIGHT: **265LBS**
HEIGHT: **6 FEET AND 5 INCHES**
WEAPONS: **MURASAME SWORD**

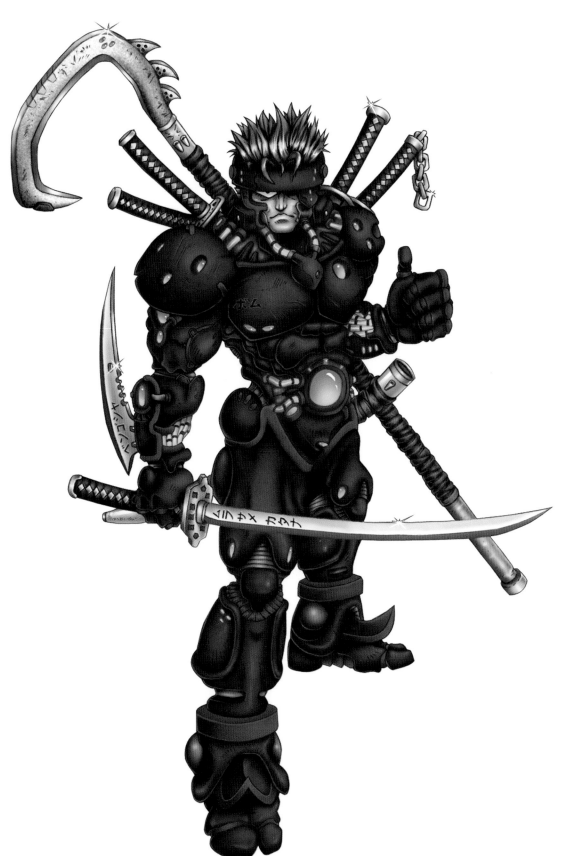

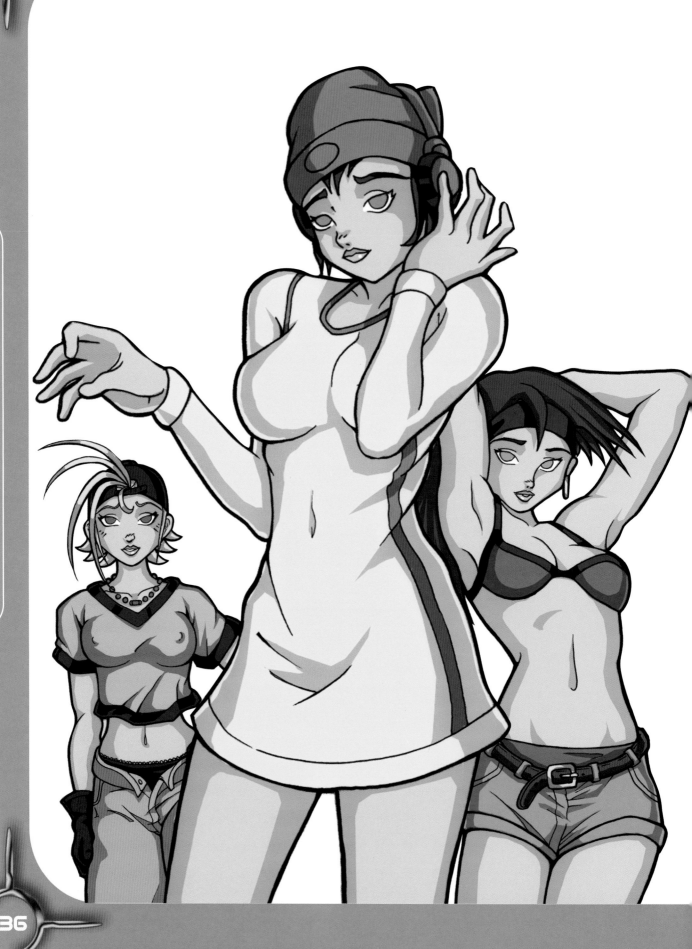

If you look very carefully, you'll notice that these lovely ladies are all very similar in terms of facial features and physique. It therefore makes you realize how important the details—such as hair, clothes, and accessories—can be in developing personalities and individual characteristics in your creations.

TEMPEST TRIPLETS

These battling teens are not just pretty faces. When their younger brother was badly injured in an unprovoked attack by a rival high school, the triplets took it upon themselves to seek justice, vowing to find those responsible. The trail led to the notorious Ring of Skulls Gang and a showdown with their ringleader, Cranium. Using a combination of ju-jitsu and street fighting, the triplets defeated Cranium and avenged their brother. They now continue their role as righters of wrongs, meting out justice as the Tempest Triplets for those who have no other recourse.

NAME: **MIIKI, AOKI, HARUKA**
AGE: **16**
HEIGHT: **5 FEET 5 INCHES**
WEIGHT: **116LBS EACH**
SCHOOL: **YUKADA HIGH**
FIGHTING SKILL: **JU-JITSU AND STREET FIGHTING**

CREATING CHARACTERS

NIKKI

There's not a lot I can say about Nikki, although the use of color was very important in getting the illustration just right! This was a Christmas card I designed and it brought a lot of cheer to those who received it! Joking aside, you can see many of the techniques I mentioned earlier, such as the shaping of the hair, the use of speculars, the folds of the clothes, and the importance of facial expression.

NIKKI

Nikki is the ultimate stealth operative! A famous fashion model, she is in demand around the world, but her high-profile lifestyle also gets her close to the rich, famous, and influential, and proves the perfect cover for her real skills as a seeker and seller of information. People underestimate Nikki at their peril!

NAME: **NIKKI**
AGE: **24**
HEIGHT: **5 FEET 6 INCHES**
WEIGHT: **120LBS**
OCCUPATION: **SPY FOR HIRE**
SKILLS: **LOCK-PICKING, HACKING, SMUGGLING**
EQUIPMENT: **JUST HER CHARM!**

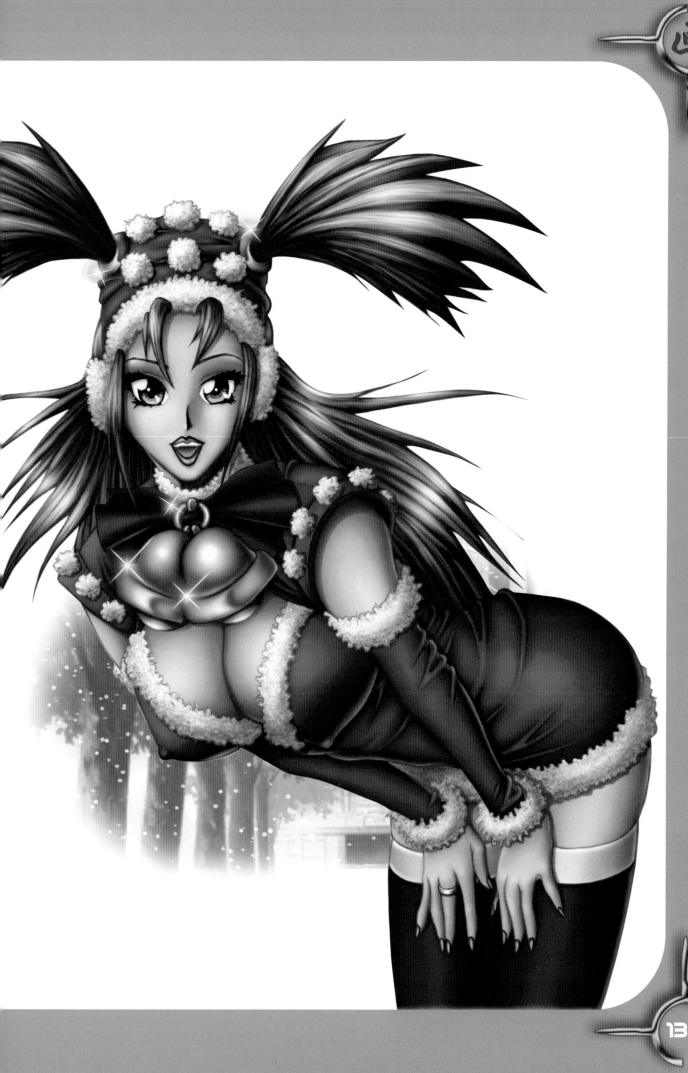

CREATING CHARACTERS

RUDY ROUGHNIGHT

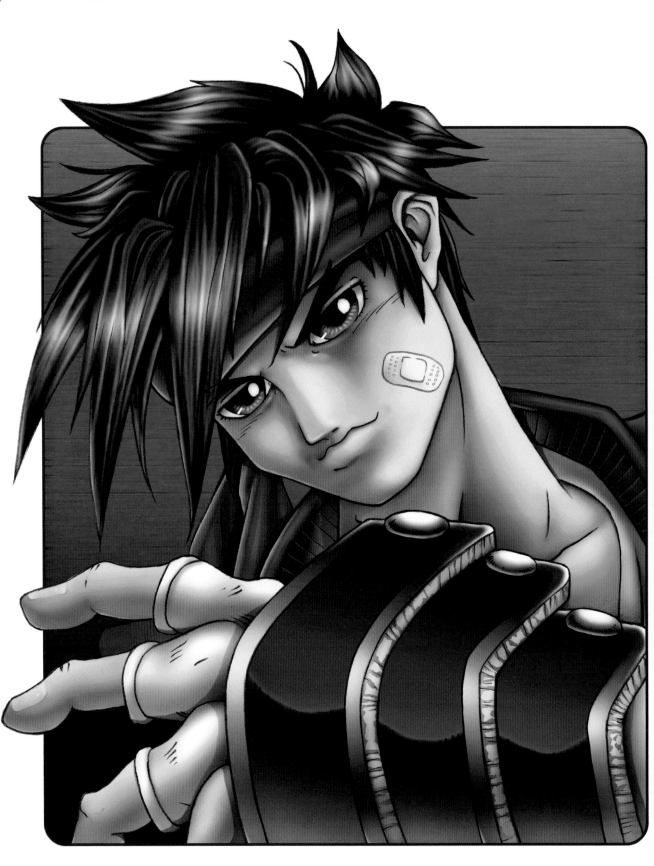

What can you tell about Rudy's background or personality from this picture? Little features can make all the difference.

What does the band-aid signify?
Is Rudy a fighter or did he cut himself shaving?

Is the frown one of aggression or confusion?

RUDY ROUGHNIGHT

Rudy is actually a character from the RPG Wild Arms. Rudy is a young Dream Chaser who was exiled from the town of Surf because of his mysterious weapon, the ARM. When he was a young boy, Rudy was much stronger than any regular child, so he was feared and became a loner, finding comfort only in the house of his grandfather, Zepet. He is one of the few people in the world who can synchronize with the ARMs, making him a forceful fighter.

NAME: **RUDY ROUGHNIGHT**
AGE: **15**
HEIGHT: **5 FEET 8 INCHES**
WEIGHT: **160LBS**
COMPANIONS: **JACK AND CECILIA**
WEAPON: **SWORD**
GREATEST FEAR: **REMAINING IN EXILE**

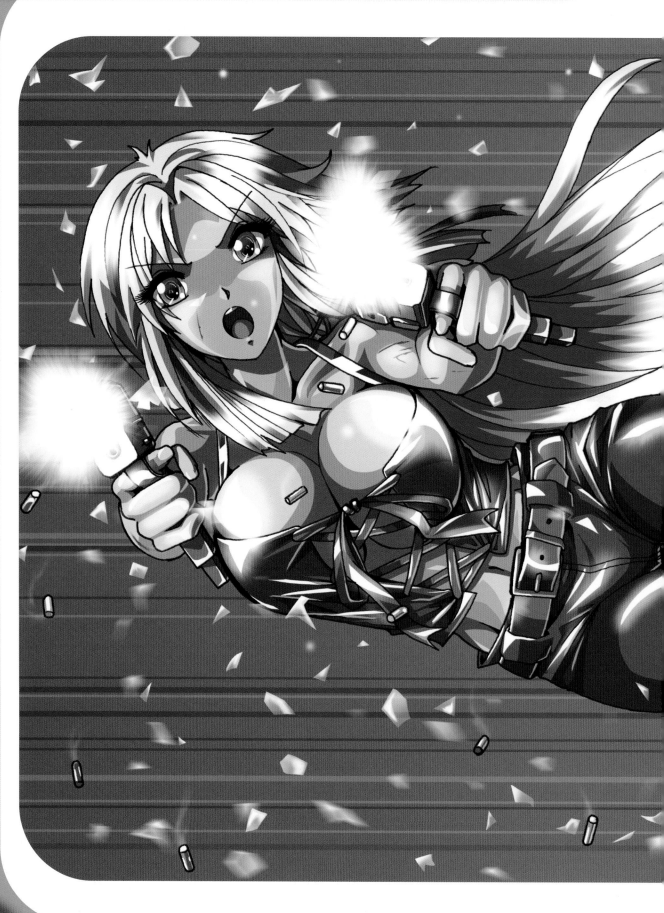

That's it for now — get drawing and have FUN!!!

Ben Krefta

Ben was born in Kent, England, in 1982. He currently enjoys his role as a free-lance designer specializing in character design for games or company mascots, as well as website and graphic design. Ben has had no formal training in any of the fields he works in—annoyingly, it's just natural talent! He has been drawing for as long as he can remember.

Ben has been a big anime and manga fan for years. Influenced by the style since playing on the Super Nintendo and having seen 'Akira' for the first time, Ben knew this was a style of art he wanted to get into.

Having always enjoyed drawing and designing his own characters, Ben started applying the clean, crisp manga style to his designs. They took on a new life, and his illustrations improved with every new design—since manga is so diverse, it's allowed Ben to have lots of fun experimenting with different style variations and the anime and manga stories themselves have opened up new possibilities and ideas.

Ben hopes to continue drawing, designing, and creating. As Ben himself says, he's got a fair few years ahead of him yet to develop and improve, so who knows what big, fun projects he'll be working on in the future!!